CW00924045

MASSACHUSETTS

ART OF THE STATE

ART OF THE STATE

MASSACHUSETTS

The Spirit of America

Text by Patricia Harris and David Lyon

Harry N. Abrams, Inc., Publishers

NEW YORK

This book was prepared for publication at
Walking Stick Press, San Francisco

Project staff:
 Series Designer: Linda Herman
 Series Editor: Diana Landau

For Harry N. Abrams, Inc.:
 Series Editor: Ruth A. Peltason

Page 1: Drawing from the log of the whaling ship *The Edward Cary*,
spring of 1858. *Christie's Images*

Page 2: *Haircut on Cape Ann* by Milton Avery, 1945. *Milton Avery Trust/
Artists Rights Society, New York*

Library of Congress Cataloging-in-Publication Data

Lyons, David, 1935–.
 Massachusetts : the spirit of America, state by state / text by Patricia Harris
and David Lyon.
 p. cm. — (Art of the state)
 Includes bibliographical references and index.
 ISBN 0–8109–5560–1
 1. Massachusetts—Civilization—Pictorial works.
2. Massachusetts—Miscellanea. I. Harris, Patricia, 1949– II. Title. III. Series.
F73.37.L96 1999
974.4—dc21 98–43099

Copyright © 1999 by Harry N. Abrams, Inc.
Published in 1999 by Harry N. Abrams, Incorporated, New York
All rights reserved. No part of the contents of this book may be
reproduced without the written permission of the publisher
Printed and bound in the United States of America

Harry N. Abrams, Inc.
100 Fifth Avenue
New York, N.Y. 10011
www.abramsbooks.com

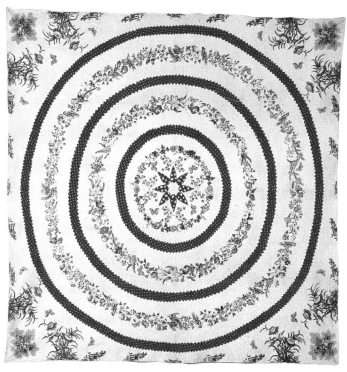

Appliqué circle quilt, Salem, c. 1845. *America Hurrah Archive, New York*

CONTENTS

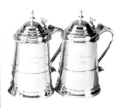

RIGHT FROM THE START

"Don't blame me. I'm from Massachusetts."

Popular post-Watergate bumper sticker

Massachusetts must be pardoned for sometimes acting like America's oldest family member at the holiday table. Nearly 400 years of history gave the Bay State a head start on the rest of the country. It is a place of many firsts: first democratic government, first public school, first to rebel against colonial rule, first to open the ports of China and Japan, first to pirate the power loom from England, first to shed blood for the Union in the Civil War. But then, Massachusetts was also first to execute a Quaker for heresy, first to hang "witches," first to riot and loot a governor's house. It was first in prohibiting the sale of alcohol (in the 1850s), first to launch an e-mail message. And it was the only state to give its electoral votes to George McGovern rather than Richard Nixon. As an anonymous scribe for the Federal Writers Project observed in the 1930s, "Massachusetts…is a State of tradition, but part of its tradition is its history of revolt."

America's hometown is Plymouth, where the Pilgrims broke bread with the Wampanoags in the first Thanksgiving feast, given such mythic weight by the passage of time. At Boston's Faneuil Hall, patriots such as Samuel Adams, James Otis, and Paul Revere set in motion the events that led to "the shot heard 'round the world" as the colonies rose in arms against their English king. (Several of those rebels nonetheless found time to sit for portraits by John Singleton Copley.) Two of the country's first six presidents were Massachusetts men, and the state that had made fortunes in the Caribbean slave trade later became the fiery angel of the Abolition movement.

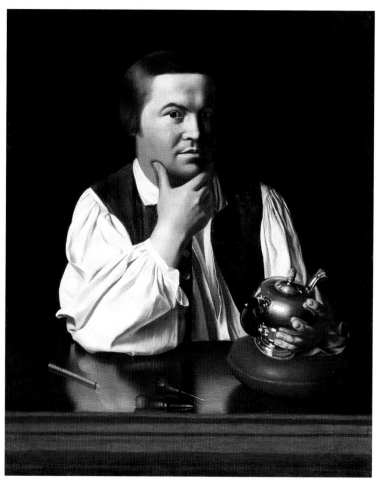

Paul Revere by John Singleton Copley, 1768. *Museum of Fine Arts, Boston*

Although the Connecticut and Housatonic river valleys in the western part of the state proved fertile enough to farm, eastern Massachusetts was rocky and barren. So the state took immediately to sea—filling its boats with codfish, selling the catch around the world, and coming home rich. That new "codfish aristocracy" spent freely on fine things, its patronage stimulating a creative spurt in fine cabinetry (Massachusetts continues to lead the studio furniture movement) and bankrolling the building of distinctive architecture in Boston and Salem. Commerce and art collaborated briefly in the 1850s to produce the Boston clippers, some of the swiftest and most beautiful vessels ever to carry sail into the wind, and Massachusetts marine painters rendered them with admiring enthusiasm.

By the mid-19th century, Dr. Oliver Wendell Holmes could announce with scant irony that "The State-House is the Hub of the universe." Massachusetts embraced the radical painting styles emanating from France and

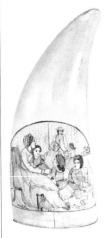

had begun to build the museums, libraries, and concert halls for which it remains famous. The state's self-assurance derives in part from its intellectual attainments. Massachusetts required universal education almost from the outset and built the first English-speaking college in the New World: Harvard. No wonder American literature was first defined by Massachusetts writers—the optimism of Ralph Waldo Emerson, the lofty practicality of Henry David Thoreau, and the dark nights of the soul limned by Nathaniel Hawthorne and Herman Melville.

Scrimshaw carving of a family scene on sperm whale tooth.
The Bostonian Society/Old State House

As its literati drove the spirit of the Bay State, its technicians and entrepreneurs drove the industry. From the mills of Lowell and the sewing machines of Elias Howe to the "instant" success of Polaroid and the biotech engineering of Genzyme, Massachusetts imagined the future and made it happen. The state's educa-

Nauset Beach, Orleans, Cape Cod. *Photo Tom Ruddeforth*

tional and cultural resources continue to draw not just leading writers, thinkers, and scientists but also visual and performing artists of all kinds. Bay State "techies" not only build computers and design software but create artworks in digital media. Countless musicians and dancers train here, and Boston's reputation for discerning audiences has made it the leading tryout town for Broadway-bound plays and musicals.

Just as Massachusetts ventured into the world to make its fortune, the world has come here, mingling new blood with the blue blood of Yankee founders. The Irish diaspora from the potato famine so swelled the state's population that by the Civil War a third of residents claimed Irish descent. Wave after wave of refugees from central, eastern, and southern Europe came ashore at East Boston later in the century. The migrations continue—now from the Caribbean and Southeast Asia—and Massachusetts grows ever richer for the diversity. ⊛

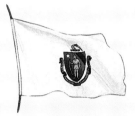

MASSACHUSETTS

"The Bay State"
6th State

Date of Statehood
FEBRUARY 6, 1788

Capital
BOSTON

Bird
BLACK-CAPPED CHICKADEE

Flower
MAYFLOWER

Tree
AMERICAN ELM

Rock
ROXBURY PUDDING STONE

Fish
COD

Dog
BOSTON TERRIER

The naive first seal of the Massachusetts Bay Colony—designed before many colonists had crossed the ocean—depicted a Native American in a grass skirt voicing the plea (in Latin), "Come Over and Help Us." The local tribes weren't quite so passive, and while the official state seal, adopted in 1780, keeps the generic Indian, he now wears a shirt and carries a bow and arrow. On the crest, above the dauntless state motto, an arm wields a broadsword.

Chickadee and mayflower

Many Massachusetts symbols commemorate specific periods of its history—the cod, on which colonial fortunes were built; the wild turkey, which Pilgrims ate at the first Thanksgiving; and the American elm: Washington took command of the Continental Army in 1775 beneath an elm on Cambridge's common. ✸

Rhodonite

"Ense petit placidam sub libertae quietam"
(By the sword we seek peace, but peace only under liberty)

State motto

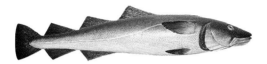

"Massachusetts"

You can tell me about the times you've spent
in the Rockies and on the Plains
Please don't think that I'm the last to say
That there ain't lots of other places in this world
That still remain beautiful and unchanged
But that's just not the same

If you could only see
I know you would agree
There ain't nowhere else to be
 But Massachusetts

From the Official Folk Song of the Commonwealth by Arlo Guthrie

Official State Heroine

Masquerading as a man and calling herself Richard Shurtleff, Deborah Samson fought bravely in the Revolution until her gender was discovered when she was wounded in battle. Later in life she lectured about her experiences and received the first military pension awarded to a woman. Each year the governor issues a proclamation observing May 23 as the anniversary of Samson's enlistment in the Continental Army.

Above: This c. 1784 carving of the "sacred" cod hangs in the State House. *Commonwealth of Massachusetts State House Art Collection. Massachusetts Art Commission. Left:* Boston terrier. *Photo J. M. Labat (Jacana)/Photo Researchers, Inc. Right:* Cushing & White liberty weathervane from Waltham, c. 1885. *America Hurrah Archive, New York. Opposite below:* Rhodonite, the state mineral. *Photo © Joyce Photo*

Boston Baked Beans

2-quart bean pot
2 pounds beans (California pea beans or York State beans preferred)
1 tsp. baking soda
1 lb. salt pork
1 medium onion
⅔ cup molasses
2 tsp. dry mustard
4 tsp. salt
½ tsp. pepper
8 tbsp. sugar

Soak beans overnight. In morning, boil them for 10 minutes with a teaspoon of baking soda. Then run cold water through beans in a colander or strainer. Dice rind of salt pork in inch squares, cut in half. Put half on bottom of bean pot with whole onion. Put beans in pot. Put the rest of the pork on top. Mix molasses, mustard, salt, pepper, and sugar with hot water to cover. Pour over beans. Put in 300° F oven for six hours. Makes 10 full portions.

*From Durgin-Park Restaurant,
established in 1826*

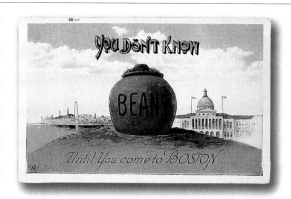

And this is good old Boston,
The home of the bean and the cod,
Where the Lowells talk to the Cabots
And the Cabots talk only to God.

*John Collins Bossidy,
toast at Holy Cross Alumni Dinner, 1910*

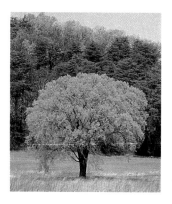

Above: Vintage postcard of "Beantown." *Collection the authors. Left:* American elm tree in spring. *Photo Adam Jones/Photo Researchers, Inc. Opposite above:* Boston cream pie. *Photo Stephen Frisch. Opposite below left:* Right whale tail. *Photo Des and Jen Bartlett/National Geographic Society. Opposite below right:* Cupola of the Old State House. *Photo Frank Siteman/Rainbow*

A Surfeit of Symbols?

Massachusetts may have more official emblems than any other state, indicating the legislature's openness to petitions from schoolchildren and other crusaders. Among others, the Bay State has an official muffin (corn), dessert (Boston cream pie), cookie (chocolate chip), polka ("Say Hello to Someone in Massachusetts"), and an official soil (Paxton soil series).

Why Commonwealth? Why Massachusetts?

The name "Massachusetts" comes from the Algonquian Massachusett tribe that lived near Great Blue Hill, just south of Boston. Colonials disagreed on the translation; roughly, it means "big hill at the mouth of the river." Massachusetts is a commonwealth rather than a state because voters rejected the 1778 draft of the state constitution, which bore the name "State of Massachusetts-Bay." For the next draft, author John Adams changed it to "Commonwealth of Massachusetts"—and this time the voters approved.

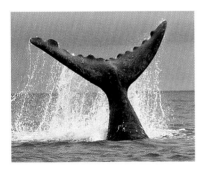

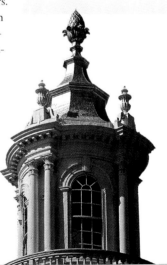

1604 Samuel de Champlain explores and maps the coast for France.

1614 Captain John Smith maps the coast for Great Britain.

1620 Plymouth founded by Pilgrims.

1628 Salem founded by Puritans.

1630 Puritans led by John Winthrop settle Boston.

1632 Boston becomes capital of the Massachusetts Bay Colony.

1635 Boston Latin School, America's first public school, opens.

1636 Harvard University founded.

1650 First American ironworks established in Saugus.

1675–76 King Philip's War between Native tribes and colonists.

1692 Salem witch trials begin.

1716 Boston Light, oldest U.S. lighthouse, is built in Boston Harbor.

1765 America's first chocolate factory built in Dorchester.

1770 Five colonists killed by British troops in Boston Massacre.

1775 Battles of Lexington and Concord begin the Revolution; colonists and British clash again at Bunker Hill.

1776 British evacuate Boston.

1788 Massachusetts becomes the sixth state.

1796 John Adams elected second U.S. president.

1798 USS *Constitution* launched from shipyard in Boston's North End.

1799 Peabody Museum founded in Salem, oldest continuously operating museum in the U.S.

1806 African Meeting House, first church built by free blacks in America, opens in Boston.

1820 Maine separated from Massachusetts.

1824 John Quincy Adams elected sixth U.S. president.

1831 William Lloyd Garrison founds anti-slavery publication *The Liberator*.

1839 Charles Goodyear first vulcanizes rubber in Woburn.

1846 First use of anesthesia demonstrated at Massachusetts General Hospital. Crane Paper Company of Dalton begins supplying paper for U.S. currency.

1851 Clipper ship *Flying Cloud* sets record from Boston to San Francisco.

1852 Boston Public Library founded.

1857 *Atlantic Monthly* begins publication.

1870 Museum of Fine Arts founded.

1872 *Boston Globe* founded.

1891 First basketball game played in Springfield.

1892 Charles and Frank Duryea build first gasoline-powered automobile in Springfield.

1895 "King" Gillette invents the safety razor; production begins in 1903.

1897 Boston opens first subway in North America. First running of Boston Marathon.

1907 Albert Champion invents the spark plug in Boston's South End.

1912 Bread and Roses strike in Lawrence marks apogee of radical labor movement. Fenway Park opens.

1914 Cape Cod Canal opens.

1918 Boston Red Sox win the World Series.

1920 Calvin Coolidge elected vice president.

1920–27 Sacco-Vanzetti case in Boston divides country on issues of ethnicity and politics.

1925 Mutual fund invented by money managers of Fidelity Investments.

1942 492 people perish in nightclub fire at Cocoanut Grove in Boston.

1960 John F. Kennedy, an Irish Catholic, elected 35th U.S. president.

1961 Cape Cod National Seashore established.

1966 Edward W. Brooke is first African American elected to U.S. Senate by popular vote.

1972 Massachusetts is only state to vote for George McGovern in presidential election.

1976 Faneuil Hall Marketplace opens and sets prototype for festival marketplaces.

1994 Seiji Ozawa Hall, the new architectural gem of Tanglewood Music Festival, opens.

1996 Central Artery Project becomes most expensive highway project in U.S. history. Boston Harbor Islands designated as National Recreation Area.

The varied landscape of Massachusetts was 450 million years in the making. To the west, the Taconic and Hoosac ranges of rolling Berkshire Hills speak of ancient continental collisions, where only the hardest minerals survived eons of erosion by ice, wind, and water. The placid Connecticut River Valley overlies a fiery rift in the earth's mantle. Moving eastward, a central plateau sheds rain and snow into dozens of rivers that once powered mills en route to the sea. Vast tracts of salt marsh, red maple swamp, and patchy beech and pine forest occupy the coastal plain; beyond these lowlands, the 1,500-mile coast unfolds—from craggy granite outcrops at Cape Ann to barren

dunelands at the tip of Cape Cod.

Although early settlers cleared almost all of interior Massachusetts, farmland is now mostly confined to parts of the central plateau and the Connecticut and Housatonic Valleys. Elsewhere, the boreal forest is reclaiming untilled fields, and through most of the upland landscape, maples, birches, and aspens put on impressive autumn colors. ✪

Left: As cleared farmland grows back in hardwood forest, Massachusetts is ablaze in the fall. *Photo Paul Rezendes*

Opposite: In the Coastal Realm by Joseph McGurl, 1995. *Private collection. Courtesy the artist*

...no man can tell the weather
anywhere but where he's from:
you'd have to have the whole of it together,
bred in your bones—the way the wind-shifts come...

...New England weather
breeds New Englanders: that changing sky
is part of being born and drawing breath
and dying, maybe, where you're meant to die.

*Archibald MacLeish, from "New England Weather"
in* New and Collected Poems, *1917–1976*

Weather Forecasting

"The Wind blowing Much from the South without rain; wormes in oak-apples; Plenty of Frogs, flyes and poysonous creatures; Great and Early heates in Spring; Year with little Wind and thunder; Flesh or fish soon putrefying in the open air."

Long range weather forecast,
Foster's Almanac, *1676*

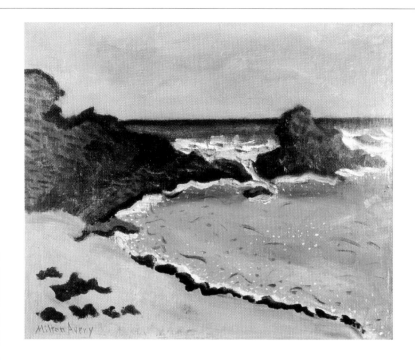

Gloucester Landscape by Milton Avery, c. 1945. Rocky Neck art colony, deemed by the Smithsonian the oldest working artists' colony in America, sits on a knob of land that juts out into Gloucester harbor. *Milton Avery Trust/Artists Rights Society*

Capes and Bays

Massachusetts and Cape Cod Bays form a double scoop of deep water between the granite jaw of Cape Ann, jutting defiantly 15 miles into the Atlantic, and the broad, 65-mile-long arc of Cape Cod, which Thoreau called "the bare and bended arm of Massachusetts." Gravelly beaches cleaved by rocky headlands in the north gradually give way, south of Boston Harbor and its drumlin islands, to long sandy beaches, clam-filled tidal flats, and the estuary salt marshes that serve as the ocean's nursery.

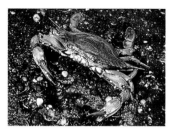

While most of the Massachusetts coastline is eroded bedrock, Cape Cod and the islands to its south—Nantucket, Martha's Vineyard, and the Elizabeths—were formed by the rubble of rocks and sand bulldozed into place by the leading edge of the Laurentian ice sheet. Still in their geological infancy, these soft headlands and vast sand dunes are unstable landforms whipsawed by wind, tide, and surf into perennially changing forms.

Left: Blue crab (*Callinectes sapidus*). Photo E. R. Degginger/Photo Researchers, Inc. Below: Edgartown lighthouse on Martha's Vineyard. Lighthouses ring Martha's Vineyard and Nantucket to warn sailors off their shallow shoals, long known as the "graveyard of the Atlantic." *Photo Gail Mooney*

"SOLITARY AND ELEMENTAL, UNSULLIED AND remote, visited and possessed by the outer sea, these sands might be the end or the beginning of a world. Age by age, the sea here gives battle to the land; age by age, the earth struggles for her own, calling to her defense her energies and her creations.…The great rhythms of nature…have here their spacious and primeval liberty; cloud and shadow of cloud, wind and tide, tremor of night and day. Journeying birds alight here and fly away again all unseen, schools of great fish move beneath the waves, the surf flings its spray against the sun."

Henry Beston, The Outermost House, *1928*

Above: Roseate Tern (Sterna dougallii) by John James Audubon, from *Birds of America.* This species is now only rarely seen around Cape Cod, but the closely related common tern is a graceful and spirit-lifting sight along the beaches. *Right: Ballston Beach by* Joel Meyerowitz, 1995. Meyerowitz is today's leading photographic interpreter of Cape Cod. Many of his best-known images were made near his home in Provincetown, at the northern tip of the Cape. *Courtesy the artist*

Stretching 40 miles, from the sandy strand of Nauset Beach at Cape Cod's elbow to the easternmost reach of land into the Atlantic at Race Point, the National Seashore preserves nearly 45,000 acres of natural habitats. Within its confines are fragile dunes, rolling beaches, tidal marshes, glacial kettle ponds, cranberry bogs, cedar swamps, and forests dominated by beech trees or a mixture of pines and oaks. Naturalists, poets, and painters are drawn to this edge of outer Cape Cod for its magically diffused light and the drama of the land, where headlands tower 175 feet above the dunes.

Established in 1961, the National Seashore is laced

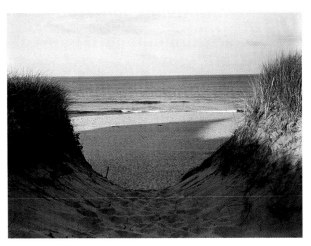

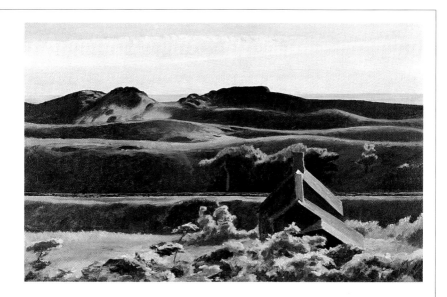

with walking and cycling trails and dotted with light-houses. Six of the Cape's best swimming beaches lie within its borders. The Old Harbor Lifesaving Museum at Race Point recalls when rescue teams at 13 such stations pulled shipwreck victims from the treacherous coastal waters. ⊛

"CAPE COD IS A ONE-STORY PLACE. EVERYTHING SITS AGAINST the horizon. Everything is in human scale."

Photographer Joel Meyerowitz, Cape Light, 1981

Hills, South Truro by Edward Hopper, 1930. The painter spent most summers in Cape Cod from 1930 until his death in 1967; his studio in Truro is now part of the National Seashore. Hopper said of the Cape: "...there's a beautiful light there—very luminous—perhaps because it's so far out to sea; an island, almost." *Cleveland Museum, of Art*

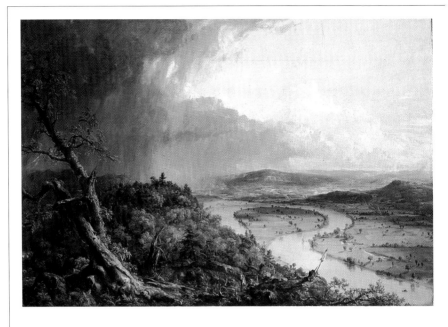

View from Mount Holyoke, Northampton, Massachusetts, after a Thunderstorm—The Oxbow by Thomas Cole, 1836. A leader of the Hudson River School, Cole applied Italian landscape traditions to America's wild country. Metropolitan Museum of Art, New York

Working Rivers

"THIS STREAM [THE CONNECTICUT RIVER] MAY, WITH MORE propriety than any other in the world, be named THE BEAUTIFUL RIVER...."

Timothy Dwight, Travels in New England and New York, 1823

The tribal peoples of Massachusetts often called themselves, their villages, and their rivers by the same names, as the three were inseparable. In a landscape dissected by more than 20 major river systems and thousands of streams, creeks, and brooks, water was often the best route for transportation.

Moreover, the valleys of the large rivers—especially the Housatonic and the Connecticut in western Massachusetts—were fertile flood plains that trapped summer heat to grow vigorous crops of corn and tobacco. The smaller rivers of the east were punctuated with *pawtuckets* (falls and rapids) where migratory alewives, salmon, shad, and sturgeon could be taken in large numbers.

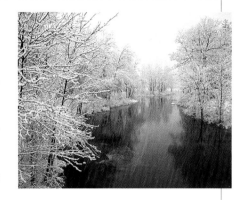

European settlers likewise gravitated to the river systems, where they established shipyards at the river-mouth harbors of the east and vast agricultural plantings in the wide western valleys. They planted inland towns at the *pawtuckets,* damming the falls to power gristmills and sawmills, later turning the slow-moving rivers into inexorable engines of the Industrial Revolution.

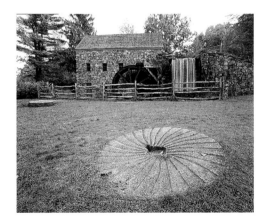

Above: Snowstorm on Tully River, Royalston. *Photo Paul Rezendes. Left:* Grinding stone and mill at Wayside Inn grist mill in Sudbury. The millstone is such an archetypal Massachusetts artifact that Jacqueline Kennedy specified that such a stone should surround the eternal flame at John F. Kennedy's grave in Arlington National Cemetery. *Photo Paul Rezendes*

> ## *"Every new aspect of the mountains...*
> ## *creates a surprise in the mind."*
>
> *Nathaniel Hawthorne, 1838*

View of the Berkshires. A backbone of quartzite ridges supports the rounded sedimentary shales of the southern end of the Hoosac Range in the Berkshire Hills. Some of the Bay State's finest farmland lies in the valleys of these gentle mountains. *Photo Jonathan Blair/Corbis*

The modest Berkshire Hills of western Massachusetts—the oldest, most eroded mountains in this hemisphere—walled off the Bay State from New York until the first railroad tunnel pierced them in 1875. Hardly as majestic as the Green Mountains to the north, the Berkshires benefited from more articulate chroniclers. Nathaniel Hawthorne was the first to seek transcendence here, journeying by oxcart in 1838 to the summit of Mount Greylock, the tallest of the peaks at 3,491 feet. Henry David Thoreau made a characteristic solitary hike up Greylock in 1844, overnighting beneath a Williams College weather observation platform.

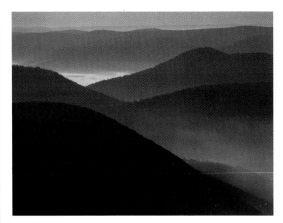

Herman Melville, Hawthorne, and Oliver Wendell Holmes scrambled up 1,735-foot Monument Mountain in an August 1850 thunderstorm. At the top they toasted Berkshire native William Cullen Bryant with champagne from a silver goblet and read aloud his poem about an Indian maiden who leaped from the cliffs to

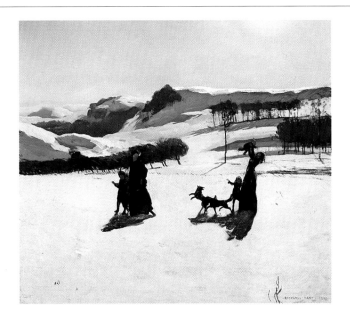

her death, over forbidden love. Melville, who stared daily at Greylock's great hump as he wrote *Moby-Dick,* made a convivial 1851 pilgrimage with 11 companions and stores of brandied fruit, champagne, port, cognac, and Jamaican rum, plus a pack of cards.

Snow Fields (Winter in the Berkshires) by Rockwell Kent, 1909. As a romantic adventurer, Kent was drawn to the most desolate stretches of Scandinavia and the high Arctic, but often turned his talents to illustrating New England winter scenes as well. *National Museum of American Art/ Art Resource*

"MAJESTY IS ALL AROUND US HERE IN BERKSHIRE, SITTING as in a grand Congress of Vienna of majestical hill-tops, and eternally challenging our homage."

Herman Melville, dedicating his novel Pierre *to "Greylock's Most Excellent Majesty," 1852*

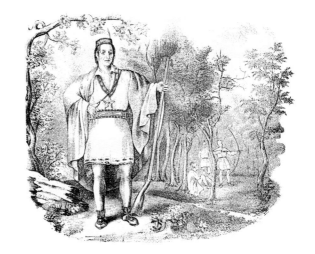

Right: Lithograph of Wampanoag chief Metacom by T. Sinclair, 1842. *Library of Congress. Below:* A fancy basket with handle made by Wampanoag weaver Emma Mitchell Safford, c. early 20th century. The materials are ash splints and sweet grass braids. *Hood Museum of Art, Dartmouth College, Hanover, New Hampshire*

The First Bay Staters

When the Pilgrims landed in 1620, Native peoples had been living in what would become Massachusetts for more than 12,000 years. The seven Algonquian nations of the region spoke dialects of a common language and practiced variants of the Eastern Woodland culture of deer hunting and fishing. The Nausets and Wampanoags of the southeast were great whale-hunters and fishermen, while the Massachusetts left behind shell middens on the Boston harbor islands that testify to 4,000 years of clambakes. Trade over great distances was common. Corn, introduced from Ohio into the Connecticut River valley around A.D. 1000, spread quickly through the

region, promoting permanent agricultural settlements that flourished until an epidemic (probably smallpox) decimated populations in 1616–17.

The arrival of Europeans spelled a quick end to traditional material culture as heavy pottery was cast aside for iron pots, leather for European cloth, and the bow and arrow for English guns. In 1675 many tribes united under Wampanoag sachem King Philip in a valiant effort to drive the English from their land. When they failed, tribal life was doomed. Many of the eastern survivors fled to Canada or adopted English ways, while the western tribes were drawn into the frontier wars between the French and English. Today only the Wampanoags retain a recognizable tribal unit, with populations concentrated at Mashpee on Cape Cod and Gay Head on Martha's Vineyard.

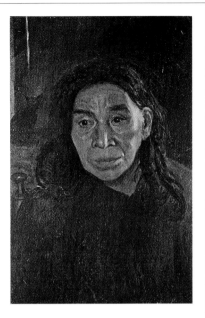

Martha Simon by Albert Bierstadt, 1857. Simon was probably the last Wampanoag living in the Fairhaven area when Bierstadt painted her. Thoreau, who once visited her, wrote in his journal, "She had half an acre of the real tawny Indian face, broad with high cheekbones." *Millicent Library, Fairhaven*

"WHEN THERE IS A YOUTH WHO BEGINS TO APPROACH manhood he is taken by his father, uncle, or nearest friend, and is conducted blindfolded into the wilderness. [After his return several months later,] if he is fat and sleek, a wife is given to him."

Isaack de Rasieres, Dutch visitor to Plymouth in 1620, describing a Wampanoag initiation

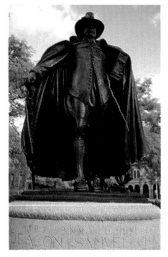

The Puritan by Augustus Saint-Gaudens, c. 1883–86. The famous statue stands in Merrick Park, Springfield. Saint-Gaudens restored the Renaissance ideal of monumental realism to American public sculpture. *Photo Eliot Cohen*

Massachusetts was stamped with a stern countenance at the outset when religious dissenters, the Pilgrims, established Plymouth on the South Shore in 1620, and religious reformers, the Puritans, settled Salem in 1626 and Boston in 1630. Fleeing persecution for their extreme Protestant beliefs, both groups sought to create a New Jerusalem in the wilderness—the Pilgrims from outside the Church of England, the Puritans from inside. Even today, one Plymouth resident in ten claims descent from the *Mayflower* Pilgrims.

By the 1640s, the Puritans controlled Plymouth along with the rest of Massachusetts through their legal charter for the Massachusetts Bay Colony. Theocratic rule gave Massachusetts its "blue laws," which banished dance, theater, and music; banned commercial activity on the Sabbath; and provided for heretics to be exiled or executed. (Only the Sunday commerce laws remain on the books.) But the Pilgrims' Calvinist principles articulated in the Mayflower Compact called for majority rule and laid the groundwork for democratic government, while the Puritan respect for Holy Writ led to free and universal education. ✪

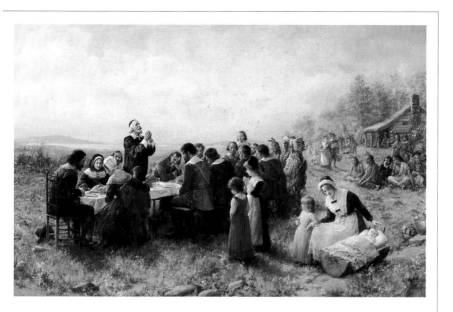

"Our harvest being gotten in,

our governor sente four men out fowling that so we might, after a more special manner, rejoyce together after we had gathered the fruit of our labours.... many of the Indians coming amongst us.... And amongst the rest, their greatest King, Massasoit, with some ninety men, whom, for three days, we entertained and feasted...."

On celebrating the first harvest, from A Relation, or Journall of the Beginnings and Proceedings of the English Plantation settled at Plimoth, in New England, *1622*

The First Thanksgiving by Jennie Brownscombe, 1914. Despite its Pilgrim origins, Thanksgiving was not celebrated as a national holiday until the 1860s and did not become associated with Plymouth until the late 19th century. *Courtesy the Pilgrim Society, Plymouth*

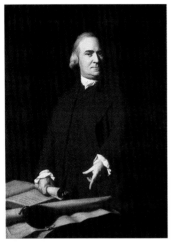

Already civilized when most of America was wilderness, the colony of Massachusetts provided the political and intellectual underpinnings for independence and was first to test the British might through insurrection. Touchstones of the American Revolution still abound in Boston: Paul Revere's house; the Old State House, which overlooks the site of the Boston Massacre of 1770; Old South Meeting House, where Samuel Adams gave the signal in 1773 to descend on Griffin's Wharf and turn the harbor into a teapot; and the spire of Old North Church, where the sexton hung lanterns to signal to Paul Revere and William Dawes which route British troops were taking to Lexington on the night of April 18, 1775.

Years of foment came quickly to a head. The "shot heard 'round the world" was fired when 700 British redcoats met 77 minutemen at dawn the next morning on Lexington's town green, killing 10 Americans and marching on to Concord to look for weapons.

Above: Samuel Adams by John Singleton Copley, c. 1772. *The Granger Collection, New York.* Copley was Boston's leading portraitist and painted many famous figures of the Revolution. *Right: The Minute Man* by Daniel Chester French, 1875. Too poor to hire a model, French dressed a statue of Apollo Belvedere in minuteman garb to make his drawings. *Photo Craig Aurness*

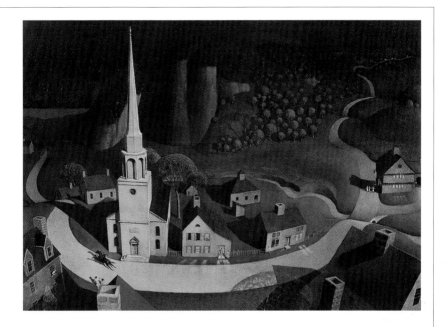

"IT WAS IMPOSSIBLE TO BEAT THE NOTION OF LIBERTY OUT OF the people as it was rooted in them from their childhood."

General Thomas Gage, commander of British forces in North America, in a 1770 letter

> By the rude bridge that arched the flood,
> Their flag to April's breeze unfurled,
> Here once the embattled farmers stood
> And fired the shot heard 'round the world.

"Concord Hymn" by Ralph Waldo Emerson, sung at the July 4,
1837 dedication of the Concord Monument

The Midnight Ride of Paul Revere by Grant Wood, 1931. Longfellow's embroidery of history in verse has entered the realm of American myth. *Metropolitan Museum of Art. © Estate of Grant Wood/VAGA, NY*

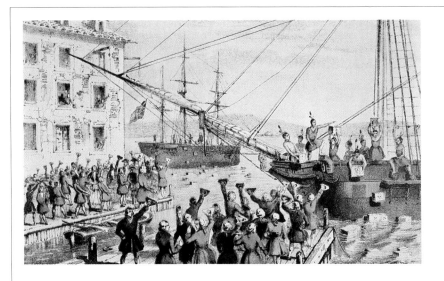

The Boston Tea Party in a 19th-century engraving. Artist unknown. *Archive fur Kunst Geschichte, Berlin/ Photo Superstock.* Political protest engravings were important tools in Revolutionary propaganda. Paul Revere's engraving of the Boston Massacre helped rally Americans throughout the colonies.

But 400 Massachusetts militia descended on the British at Concord Bridge, and the latter were routed and driven back to Boston.

Within days, 16,000 New England volunteers converged at Cambridge and laid siege to the British garrison. London sent reinforcements by sea, and in June British marines and colonists clashed again at the Battle of Bunker Hill. The siege wore on another eight months until the new Continental Army, under George Washington, forced the king's troops to leave under the guns on March 17, 1776—still celebrated in Boston as Evacuation Day. ☻

Those British Red Coats

In his book *Paul Revere's Ride,* David Hackett Fischer describes the famous—and famously uncomfortable—uniforms of King George's troops: "Both coats and jackets were made of a coarse red woolen fabric that was strong and densely woven, and meant to stand hard service. After the battle, Dover militiaman Jabez Baker carried home one of these red coats as a souvenir. In the New England way, it was put to work as a scarecrow in the fields. So sturdy was its cloth that it was still in service as late as 1866, a tattered survivor of ninety New England winters and an impressive testament to the durability of its sturdy British cloth."

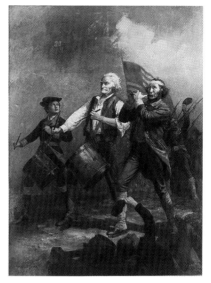

Rally, Mohawks!
Bring out your axes,
And tell King George we'll pay no taxes
On his foreign tea...

"The Rallying of the Tea Party,"
a Boston street ballad, 1773

Above: The Spirit of '76 by Archibald M. Willard, c. 1876. The original of this fabled image hangs in the Selectmen's Meeting Room in Abbot Hall, Marblehead. Photo Len Wickens. Left: Paper doll of a British soldier in the Revolution, Boston, c. 1840–50. Museum of American Folk Art

Already bustling with movements to reform prisons, schools, churches, political parties, and labor organizations, Massachusetts emerged in the 1830s as a hotbed of the antislavery movement. In 1831 William Lloyd Garrison established his abolitionist journal in Boston and called for the immediate emancipation of all persons in bondage. A year later Bostonians formed the New England Anti-Slavery Society, which swiftly spread across the North as the American Anti-Slavery Society. Bitterly opposed to the Fugitive Slave Act, the abolitionists set up Underground Railway stations for slaves on their way to freedom in Canada.

William Lloyd Garrison, c. 1830s. *The Granger Collection, New York Right:* Abolitionist broadside warning escaped slaves of peril, 1851. *The Bostonian Society/Old State House*

Massachusetts was first to answer Lincoln's call to arms in the Civil War, sending among other troops the 54th Massachusetts regiment. The first African-American regiment from any state, the 54th was led by youthful Colonel Robert Gould Shaw, an abolitionist "of gentle birth and breeding."

CAUTION!!
COLORED PEOPLE
OF BOSTON, ONE & ALL,
You are hereby respectfully CAUTIONED and advised, to avoid conversing with the
Watchmen and Police Officers
of Boston,
For since the recent ORDER OF THE MAYOR & ALDERMEN, they are empowered to act as
KIDNAPPERS
AND
Slave Catchers,
And they have already been actually employed in KIDNAPPING, CATCHING, AND KEEPING SLAVES. Therefore, if you value your LIBERTY, and the Welfare of the Fugitives among you, Shun them in every possible manner, as so many HOUNDS on the track of the most unfortunate of your race.
Keep a Sharp Look Out for
KIDNAPPERS, and have
TOP EYE open.
APRIL 24, 1851.

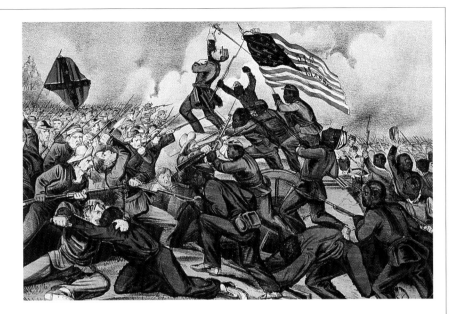

Their monument sticks like a fishbone
in the city's throat.
The Colonel is as lean
as a compass-needle....

He is out of bounds now. He rejoices in man's lovely,
peculiar power to choose life and die—
when he leads his black soldiers to death,
he cannot bend his back.

*Robert Lowell, from "For the Union Dead," 1959,
on Augustus Saint-Gaudens's memorial to Colonel Shaw
and the 54th Massachusetts*

The all-black 54th
Massachusetts leads the
charge on the Confed-
erate Fort Wagner in
South Carolina on July
18, 1863. Half the regi-
ment, including its com-
mander, Colonel Robert
Gould Shaw, died in this
battle. Color lithograph
by Currier & Ives, 1863.

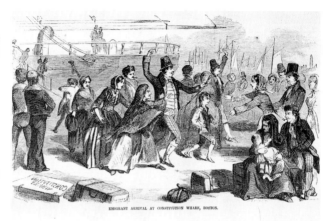

Emigrant Arrival at Constitution Wharf, Boston. Illustration from *Ballou's Pictorial,* 1857. Appalled by the influx of immigrants in the mid-19th century, the Bay State voted the xenophobic Know-Nothing Party into power. Taking immigrants under their wing, the Democrats came to dominate state politics. *Boston Public Library*

EMIGRANT ARRIVAL AT CONSTITUTION WHARF, BOSTON.

The "Yankee" Mystery

New England and New York vie for the origins of this American epithet. Some sources say the word derives from the Dutch "Janke," a diminutive of John, and was first used in colonial New Amsterdam. Bay Staters believe that "Yankees" was how the Wampanoags pronounced "English"— their language had no "l." sound and all nouns began with consonants.

New Americans

The Wampanoags called the first immigrants "Yankees," and the name stuck as English families dominated Massachusetts for 200 years. But a trickle of Irish immigrants in the early 1800s became a deluge when the potato blight struck Ireland in 1845–52. By 1855, Boston's population was one-third Irish.

By 1880, East Boston was America's second-largest immigration center as Eastern European Jews, Poles, and Lithuanians, southern Italians, and a host of Balkan peoples fled the wars, pogroms, and famines of Europe. At the same time, French Canadians streamed over the border to find work, and Chinese workers, finished with the railroads, descended on Boston to lay the first telephone lines. Many immigrants found work in the leather and textile mills of eastern Massachusetts, where the radical wing of

the American labor movement made its greatest advances. The high-water mark of the International Workers of the World was perhaps the 1912 "Bread and Roses" strike of Lawrence's textile mills.

Immigration continues, with most new residents arriving from the Caribbean islands and Southeast Asia. Yankee Massachusetts has become a polyglot society of global cultures— Cambodian, French-Canadian, Haitian, Irish, Italian, and Portuguese among them.

"No Irish need apply"

Common 19th-century "Help Wanted" sign

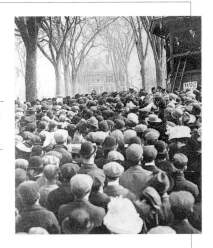

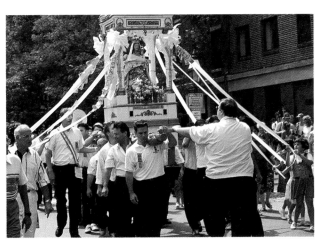

Above: A labor leader addresses the crowd from a stand on Lowell Common during the Bread and Roses strike, 1912. *Boston Public Library. Left:* Saint's day festival in Boston's Italian North End neighborhood. *Photo Susan Cole Kelly*

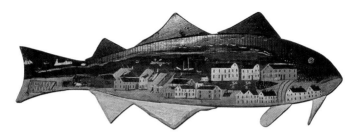

Sacred Cod and Mighty Whale

Below: The Dory, woodblock print by B. J. O. Nordfeldt, c. 1916. *Provincetown Art Association and Museum*

A painted wooden "Sacred Cod" has hung in the Massachusetts State House since 1784, honoring the basis of the Bay State's early fortunes. Salted and dried, cod was sold to Europe and traded in the West Indies for molasses to distill into rum. The greatest of the fishing ports was Gloucester on Cape Ann, where the

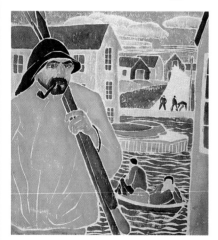

first two-masted fishing schooners were launched in 1713 to harvest nearby cod and mackerel. A larger version, the Grand Banks schooner, was devised in the 19th century to catch halibut in the distant waters off Newfoundland.

Nantucket settlers mimicked the Wampanoags by hunting whales in their coastal waters, and the island became America's first whaling port in the late 1600s. But as whale populations shrank, whalers had to search ever more distant waters; thus ships grew huge enough to hunt the South Pacific on voyages of a year or more, and New

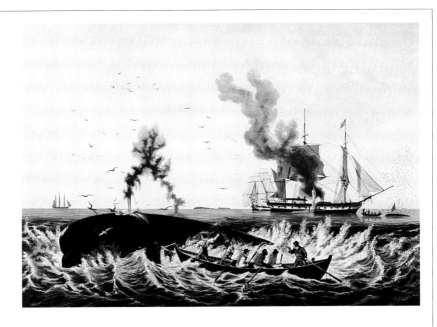

Bedford, with its deeper harbor, became the more important port. By 1880, however, kerosene replaced whale oil as a fuel and early plastics obviated the need for baleen—spelling the end of American whaling.

"BUT THOUGH THE WORLD SCOUTS AT US WHALE HUNTERS, yet does it unwittingly pay us the profoundest homage; yea, an all-abounding adoration! For almost all the tapers, lamps and candles that burn round the globe, burn, as before so many shrines, to our glory!"

Herman Melville, Moby-Dick, *1851*

The Whale Fishery, The Sperm Whale in a Flurry. **Color lithograph by Currier & Ives, c. 1870s** *Opposite above:* **Carved wooden codfish depicting Marblehead by John Orne Johnson Frost, c. 1920s.** *Marblehead Historical Society*

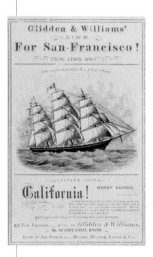

Bay State traders amassed great wealth in the early 18th century "Triangle Trade." They exchanged salt cod for molasses in the West Indies, distilled the molasses into rum, traded the rum for slaves in Africa, and the slaves for more molasses and cash in the West Indies. When Britain shut Massachusetts traders out of Caribbean ports, they sailed their "East Indiamen" around Cape Horn to trade trinkets for furs in the Pacific Northwest, furs for silks and porcelain in China. Elegant mansions sprang up from Boston to Salem to Newburyport, and their sea captain owners filled them with the wonders of the world.

Above: Advertisement for the clipper ship *California,* c. 1850s–60s. *The Bostonian Society/ Old State House. Right: His First Voyage* by Charles W. Hawthorne, 1915. Hawthorne put Provincetown on American Impressionism's dance card by founding the Cape Cod School of Art in 1899. *Provincetown Art Association and Museum*

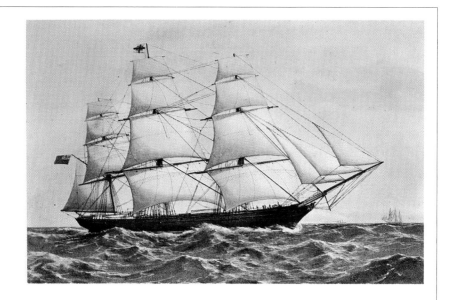

"NEVER, IN THESE UNITED STATES, HAS THE BRAIN OF MAN conceived, or the hand of man fashioned, so perfect a thing as the clipper ship. In her, the long-suppressed artistic impulse of a practical, hard-worked race burst into flower. The *Flying Cloud* was our Rheims, the *Sovereign of the Seas* our Parthenon, the *Lightning* our Amiens; but they were monuments carved from snow. For a brief moment of time they flashed their splendor around the world, then disappeared with the sudden completeness of the wild pigeon."

Samuel Eliot Morison, The Maritime History of Massachusetts, *1941*

The clipper ship *High-flyer*, weighing 1,111 tons. Built just before the clipper trade shifted to 2,000-plus tonnage, the *Highflyer* exhibited the genre's 5:1 ratio of length to breadth and the sharp, hollow bow that sliced through, rather than smashing into the waves. *Bridgeman Art Library International, Ltd.*

The Most Practical Navigator

Salem-born Nathaniel Bowditch revolutionized navigation with his 1802 book *The New American Practical Navigator*. The self-taught astronomer and mathematician learned the basics of navigation on five merchant marine voyages. His book not only corrected many earlier mathematical tables for astronomical navigation, but also introduced a simple method to determine longitude by calculating the angle of the moon to the sun or certain stars. Nearly two centuries later, the revised *Practical Navigator* remains the bible of deepwater sailors.

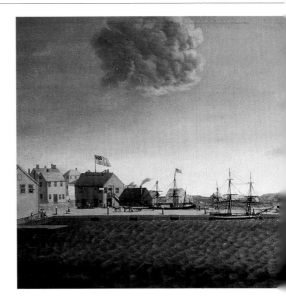

California gold fever sparked a demand for swifter trips around Cape Horn. The solution was the Yankee clipper—a veritable cloud of sail over a fast, sharp hull. Although the design originated in New York, the fastest and largest clippers came from the East Boston boatyards of Donald McKay—sailing vessels that could run 400 miles a day before the wind. But the clipper's narrow hold was suited only for premium cargoes and the overload of sail made most of them short-lived. By the the Civil War, Massachusetts traders had become financiers—building banking fortunes and financing railroads that would replace the clippers in transcontinental transportation. ⦿

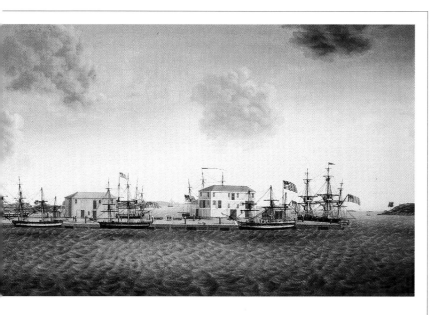

Our captain stood upon the deck,
A spy-glass in his hand,
A viewing of those gallant whales
That blew at every strand.
Oh, your tubs in your boats, my boys,
And by your braces stand,
And we'll have one of those fine whales,
Hand, boys, over hand!
So, be cheery, my lads! may your hearts never fail!
While the bold harpooner is striking the whale!

From the sailor's song "Captain Bunker," as related in Moby-Dick, *1851*

Above: Crowninshield's Wharf *by George Ropes, 1806. Peabody Essex Museum, Salem. Photo Mark Sexton. Opposite:* Figurehead of a woman, from the ships *Caroline* and *Maritana.* This figurehead supposedly bears a curse; both ships met with disaster at sea. *The Bostonian Society/Old State House*

Massachusetts entrepreneurs launched America's transformation from an agrarian to an industrial society in the 1820s when they created Lowell on the banks of the Merrimack River. For the first time on a grand scale, its mills brought together all the machinery necessary to process raw fiber into finished cloth. By the 1840s, the six miles of canals and towering brick mills

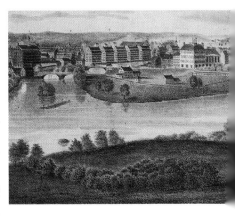

became a must-see attraction for European visitors, rivaling Niagara Falls. Lowell mills rolled out nearly a million yards of cloth per week until the

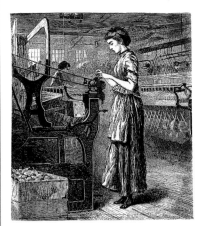

Civil War: the nation's largest concentration of industry.

The paternalistic factory system attracted the unmarried daughters of farmers and provided them with supervised boardinghouses and educational pursuits—a far cry from what William Blake called "the dark, satanic mills" of England. The "mill girls" broke the mold of reticent femininity, publishing their own literary magazine and organizing America's

first strikes. As Irish immigrants flooded in during the 1840s, they displaced Yankee women at the looms. In later decades mill workers were drawn from French Canadian, Italian, and central European arrivals. Lowell's last textile mills closed in the 1950s; the Lowell National Historic Park was created in 1978 to preserve the sites and pass down the origins of America's Industrial Revolution. ☉

> We spin all day, and then, in the time for rest,
> Sweet peace is found, A joyous and welcome guest
> Despite of toil we all agree, or out of the Mills, or in,
> Dependent on others we ne'er will be,
> So long as we're able to spin.
>
> *"Song of the Spinners,"* c. 1845

A View of Lowell by E. A. Farrar, illustration from *Gleason's* magazine, 1852. Lowell, with its 35 cotton mills, was the state's chief industrial center after Boston in the late 19th century. *Opposite:* Woman tending a loom, woodcut by Winslow Homer. "Mill girl" turned author Lucy Larcom recalled, "I could so accustom myself to the noise that it became like a silence to me." *Both, American Textile History Museum, Lowell*

Fruits of Their Labors

Massachusetts bore fruit from the outset, with the orchards of Nashoba Valley west of Boston producing cider and cooking apples for local consumption and export by the early 18th century. "Johnny Appleseed," the horticulturist and missionary who spread apple seedlings and the Gospel through the heartland, was born John Chapman in the orchard country of Leominster in 1774. By 1900, more than 100 named apple varieties were grown commercially in the state.

Amateur gardener Ephraim Wales Bull unveiled his Concord grape at the 1852 Massachusetts Horticultural Society exhibition as "a grape for the millions." The sweet and sturdy Concord was immediately popular with home growers and its commercial success was assured when New Jersey dentist Thomas Welch began selling pasteurized Concord grape juice for temperance-minded church services.

Above: Johnny Appleseed postage stamp. *Private collection. Below:* Cranberries are "wet" harvested in a Carver bog for use as processed cranberries. After flooding the bog, growers "beat" the vines to loosen berries, then corral the floating fruit and pump it into trucks. *Photo Margo Granitas/The Image Works. Opposite: Autumn in New England— Cider Making by Currier & Ives, c. 1857–1907. Photo Superstock*

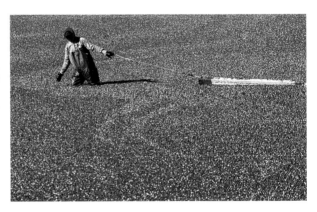

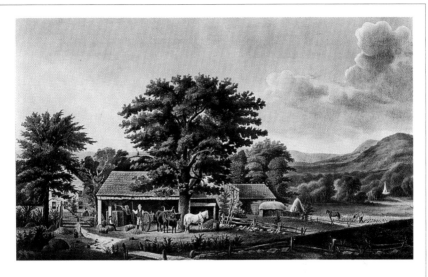

Today, the cranberry is the Bay State's chief fruit crop. Nutrient-poor, acidic bogs in the southeast produce nearly half the 400-million-pound national crop. Cranberries were used by the Algonquians in pemmican and named by the Pilgrims, who thought the berry's pale pink blossom resembled the head of a crane. First cultivated commercially in Dennis on Cape Cod in 1816, the sour fruit gained popularity only when cheap West Indies sugar became available in the mid-19th century. The Plymouth-based Ocean Spray growers' cooperative sells 70 percent of the world's cranberry crop.

Some Massachusetts Apples

Cox Orange Pippin
English Beauty
High Top Sweet
Maiden's Blush
Malinda
Opalescent
Peck's Pleasant
Salome
Sops of Wine
Sweet Winesap
Westfield-Seek-No-Further

> ## *"Mr. Watson, come here. I want to see you."*
>
> *Alexander Graham Bell to his assistant, in the first telephone call*

Bright Ideas

Massachusetts has long capitalized on the bright ideas of its thinkers and inventors. Alexander Graham Bell made the first telephone call in 1876 from Boston, speaking the now-famous words, "Mr. Watson, come here"—and Boston became the first city in the world extensively wired for phone service. Bell later worked at Boston University, setting a pattern of academic affiliation that endures. Massachusetts Institute of Technology professor Harold Edgerton revolutionized photography when he created the electronic flash lamp in 1931 as a way to examine fast-moving machine parts. Edwin Land investigated the properties of polarized light in his Harvard laboratory, leaving in 1932 to form the eventual Polaroid Corporation; he unveiled

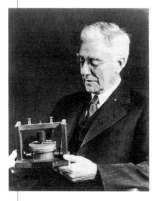

Above: Dr. Thomas A. Watson, holding a replica of the first telephone, made by him for Alexander Graham Bell, June 3, 1875. This photo was taken in 1931. *Courtesy AT&T Photo Center. Right:* Alexander Graham Bell sitting in his tetrahedral chair. *Photograph by Mark Marten. Library of Congress/Photo Researchers, Inc.*

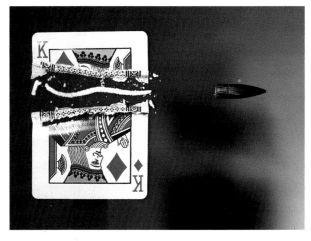

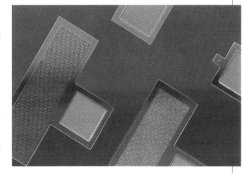

Left: *Cutting the Card Quickly* by Harold Edgerton, 1964. Edgerton's invention of the electronic flash began as service to science but soon passed into the realm of art, as the millisecond exposures made possible with his device made visible actions too fleeting for the eye to perceive. *The Harold E. Edgerton 1992 Trust. Courtesy Palm Press, Inc.* Below: *Diamond Electron Emitters* by Felice Frankel, 1997. Frankel's photographs are visual representations of scientific concepts. *Courtesy the artist*

instant photography in 1947. During World War II, Harvard mathematician Howard Aiken directed the development of the first electronic computer, designed chiefly to compute ballistics tables for navy artillery. Many early computer researchers at MIT spun off their own companies in the 1950s and '60s, building headquarters outside Boston along Route 128, "America's Technology Highway." One firm that stayed in Cambridge—Bolt, Beranek, and Newman—helped build an Internet prototype in the 1960s, and in the early 1970s issued the first e-mail message. History does not record if it was more eloquent than Bell's plea to Watson.

Above: Harvard cigarette silk collectible, 1913. Such promotional silks were packaged as premiums with cigarettes from around 1900–20. A College Series in 1913 portrayed the major U.S. colleges and universities. *Private collection* *Right:* Harvard takes on Yale in a lacrosse match. *Photo Buck Ennis/Stock Boston*

Mark Twain observed that New Yorkers ask, "How much does he have?" while in Boston the question is: "What does he *know*?" Higher education has been at the core of the state's identity from the first. The Puritans established a college in "Newtowne" in 1636 "to advance Learning and perpetuate it to Posterity." When young Charlestown cleric John Harvard died two years later, leaving his books and half his estate (£1,700) to the fledgling school, it became Harvard College and the town Cambridge, after the English university city.

Many of the state's private colleges and universities can trace their 19th-century origins to similar religious sponsorship, including Boston University, Boston College, Mount Holyoke, and Amherst College. Reform movements in the late 19th century helped create other significant temples of learning. Women's emancipation was reflected in the founding of Wellesley College in 1870, Smith

College in 1875, Radcliffe College (now merged with Harvard) in 1879, and the career-minded Simmons College in 1899. Practical and technical education enjoyed a simultaneous boom, leading to the creation of the Massachusetts Institute of Technology (MIT) in 1861 and both the University of

Massachusetts and Worcester Polytechnic Institute in 1865. The Massachusetts College of Art, founded in 1873 to educate artists and designers for Bay State industry, remains America's only publicly supported, independent four-year college of art and design. ⊕

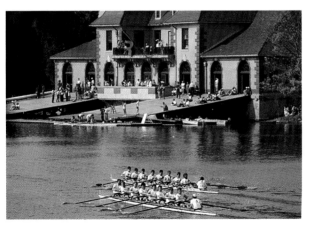

Above: Engineer Anita Flynn holds a model of an insect robot, a product of the Mobile Robot Project, operating since 1985 at MIT's Artificial Intelligence Lab. This research has led to innovative uses of robotic technology in industry and medicine. *Photo Peter Menzel/Stock Boston. Left:* Rowing shells in the Head of the Charles regatta, the world's largest two-day rowing event, pass the Radcliffe Boathouse on the Charles River, Boston. "Rowing crew" is a venerable Ivy League tradition. *Photo Lou Jones*

Fitz Hugh Lane was born in Gloucester in 1804. As a member of the sixth generation of Cape Ann Lanes, he was steeped in the maritime scene, imprinted by the play of light in clouds and by the shape and motion of waves. The first American maritime painter of note, Lane was as much concerned with light as with the scene it illuminated. His own words perhaps best describe his aims: in an 1857 letter about a new painting, Lane rhapsodized that "the effect is midday light, with a cloudy sky, a patch of sunlight thrown across the beach and breaking waves." A century after his death critics hailed him as an early "luminist."

Lane taught himself to draw in childhood and at age 28 he apprenticed himself to a Boston lithographer. In 1847, he returned to Gloucester to work full time in oils, in which his training in line and detail served him well. Until his death in 1865, Lane's vivid paintings captured Gloucester as it grew. Many great artists painted Cape Ann later on—Winslow Homer, Edward Hopper, Marsden Hartley, Milton Avery, Mark Rothko, and Barnett Newman among them. But no one saw its light like Fitz Hugh Lane. ⊛

The Fort and Ten Pound Island, Gloucester by Fitz Hugh Lane, 1848. *The Newark Museum/Art Resource. Opposite above: Fitz Hugh Lane* by Robert Cooke, 1835. *Courtesy American Antiquarian Society. Opposite below: Rafe's Chasm, Gloucester, Massachusetts* by Fitz Hugh Lane, 1853. *Christie's Images*

The Puritans of the Massachusetts Bay Colony vigorously suppressed other faiths, banishing nonconformists such as Anne Hutchinson and Roger Williams—who founded communities in Rhode Island—and martyring many Quakers. The most lasting Puritan legacy may be the white spires of Congregational churches on town greens statewide. America's first Bible-based revival, the "Great Awakening," began in 1740 in Northampton, touched off by Congregational preacher Jonathan Edwards's sermon "Sinners in the Hands of an Angry God."

Despite early intolerance, Massachusetts proved fertile religious ground. Yankee ingenuity and pious mysticism found expression among the

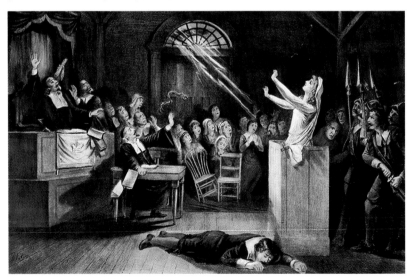

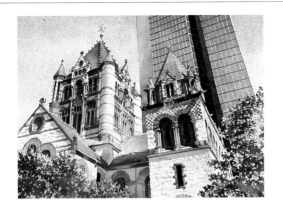

Boston's Trinity Church and its Copley Square neighbor, the John Hancock Building, watercolor by Robert Comazzi, 1998. *Kougeas Gallery, Boston. Opposite: A Witch Trial at Salem, Massachusetts, in 1692.* Artist unknown, 1892. *The Granger Collection, New York.* Puritan intolerance reached its apogee in Salem in 1692–93, when hysterical accusations of witchcraft proliferated. Before more rational heads prevailed, 20 accused witches were put to death, most by hanging. Remembered as one of the darker stains on Bay State history, the witch trials inspired Arthur Miller's play *The Crucible.*

Shakers; their community in Hancock is now a museum. Launched in the U.S. in 1776 at King's Chapel in Boston, Unitarianism spread the gospel of human perfectibility, serving as a wellspring of social reform. The world headquarters of the Unitarian-Universalist Society remains in Boston. And the First Church of Christ, Scientist, founded by Mary Baker Eddy of Lynn in 1879, anchors the worldwide Christian Science faith from its 14-acre complex in Boston's Back Bay. ☉

"I TELL YOU STRAIGHT, MISTER——I HAVE SEEN MARVELS IN THIS court. I have seen people choked before my eyes by spirits; I have seen them stuck by pins and slashed by daggers. I have until this moment not the slightest reason to suspect that the children may be deceiving me."

Deputy Governor Danforth in act 3 of
The Crucible *by Arthur Miller, 1954*

Right: Beacon Hill, from Bowdoin Street, lithograph by J. H. Bufford, 1858. *Library of Congress Below:* The townhouses on Beacon Hill's Acorn Street were built as homes for tradesmen and servants who worked in the neighborhood mansions. *Photo Eric Roth Opposite right:* Quincy Market, foreground, is the centerpiece of Boston's festival marketplace, a prototype for similar redevelopments around the East Coast. *Photo Lindsay Hebberd*

Sculpting Boston

As soon as the Puritans landed, Boston began what historian Walter Muir Whitehill called "its perennial occupation of making room for itself." Although early settlers shaved down bumps and hillocks on their peninsula to fill its marshy shores, modern Boston didn't really begin to take shape until the 1790s. The Mount Vernon Proprietors bought up the rocky pastures of three adjacent hills and lopped off the top 50 feet to create a single slope. Sent rolling down on a gravity railroad, the debris was spread on the banks of the Charles River to expand what became known as Beacon Hill. Boston Brah-

mins swiftly colonized the south side with elegant mansions, while the north side filled with tenements for the families of laborers and servants.

America's most ambitious public works project to that time, the filling of Back Bay, began in 1857. Over 25 years, developers added 450 prime acres to Boston's original 783 by filling in more than a mile of tidal marshes. Back Bay soon eclipsed Beacon Hill as the city's fashionable address, and the showcase houses built on the New Land (as older families derided it) constitute a block-by-block chronology of domestic architectural vogue in the 19th century.

"GENESIS 1.9 WOULD HAVE MADE A GOOD MOTTO FOR the new city: *Let the waters under the heaven be gathered together unto one place, and let the dry land appear: and it was so.*"

Walter Muir Whitehill, Boston: A Topographical History, *1959*

The Massachusetts State House, Charles Bulfinch's civic master-piece that influenced many other state capitols, crowns Beacon Hill on the site of John Hancock's cow pasture. The cornerstone was laid on July 4, 1795, by Samuel Adams and Paul Revere in his capacity as Grand Master of the Masons. Revere returned in 1802 to cover the dome with copper sheathing, which was later gilded. *Photo Rob Crandall/The Image Works*

RAIL AND ROAD

Below: Boston's South Union Station opened in 1899. *Opposite above: Big Dig 2* by Carolina Reyes, 1997. Reyes, one of many Boston artists documenting the massive earthworks project, has an expansive view of excavation for the Massachusetts Turnpike extension from the roof of her South Boston loft. "Changes in the use of land intrigue me," she says. *Kougeas Gallery. Opposite below:* Poster advertising the Hoosac Tunnel, c. 1880–1900. *Library of Congress/Corbis*

The Bay State's dense population and complex geography have called for pioneering solutions to move people and goods around. In 1851, the Boston and Albany Railroad started digging the nation's first major railroad tunnel: the 25,000-foot Hoosac Tunnel between the towns of Florida and North Adams. The 24-year undertaking cost $14 million and took 195 lives.

Boston scored another American first when its subway system debuted in 1897 with two stations and a hand-dug tunnel. Today the Massachusetts Bay Transportation Authority ("the MTA" in the famous song) runs a network of 1,000-plus miles of subway and trolley lines, carrying nearly 1 million people each weekday. An epic solution to near-paralysis on Boston's elevated Central Artery highway is the Big Dig, the largest highway project in U.S. history. At a cost of $10.8 billion (and rising), the Big Dig will link the Massachusetts Turnpike to Logan Airport and replace the rusting highway with 10 lanes of underground road as well as a surface park that reunites Boston with its waterfront. ◉

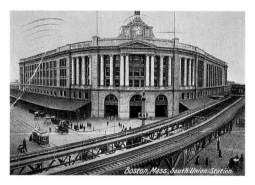

Boston, Mass., South Union Station.

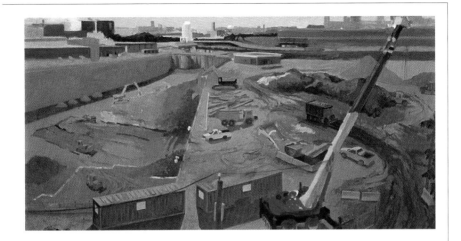

"[W]E MIGHT START TO CONCEIVE OF THE BIG DIG AS MORE than a job, but also an aesthetic adventure: a last flourish of heroic Modernism, a monument to the industrial sublime....human handiwork at its most spectacular. Regard it...as conceptual art at its most thrilling and efficacious."

Mark Feeney, Boston Globe, *May 31, 1998*

"Charlie on the MTA"

Let me tell you the story of a man named Charlie
on that tragic and fateful day.
He put ten cents in his pocket, kissed his wife and family,
went to ride on the MTA.

Did he ever return? No, he never returned....

Lyrics by Jacqueline Steiner and Beth Lomax Hawes;
1949 campaign song protesting five-cent hike in MTA fares

BOSTON PARK GUIDE

INCLUDING MUNICIPAL AND METROPOLITAN SYSTEMS WITH MAPS AND ILLUSTRATIONS PRICE 25 CENTS

BY SYLVESTER BAXTER

Olmsted's Visionary Landscapes

More than a century after its completion, Boston's Emerald Necklace remains Massachusetts' most enduring work of public art. In the 1870s, the Boston Parks Commission asked landscape architect Frederick Law Olmsted to design a park system that would rival his New York and Chicago show-pieces while addressing public health problems spawned by overcrowding. Olmsted's solution was brilliant and sweep-ing, linking the existing urban refuges of Boston Common, the Public Garden, and Commonwealth Avenue Mall to a string of countryside parks that would girdle the core city with soothing green. Olmsted transformed the swamps of the Fenway into a winding, streamside gardenscape; created

Above: Poster promoting the *Boston Park Guide,* lithograph by Charles H. Woodbury, 1895. *Virginia Museum of Fine Arts, Richmond. Right: Children Sledding, Public Garden, Boston* by Aiden Lassell Ripley, 1927. The Public Garden remains a popular sledding, snowshoeing, and cross-country skiing venue in the rare winters when Boston receives a heavy snowfall. *Vose Gallery*

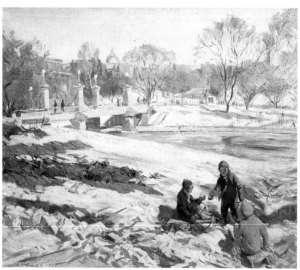

woodsy carriage paths along Muddy River to link up with
Jamaica Pond; and designed a tree-lined boulevard to anchor
the stately displays of the Arnold Arboretum and Franklin
Park's long vistas. He rightly prophesied that some plantings
would require a century to fulfill his plan—his vision is only
now reaching maturity.

"THE BEAUTY OF A PARK SHOULD BE...THE BEAUTY OF THE
fields, the meadow, the prairies, of the green pastures, and
the still waters. What we want to gain is tranquility and rest
to the mind."

Frederick Law Olmsted, "Public Parks and the Enlargement of Towns," 1870

The Arnold Arboretum,
one link in the Emerald
Necklace chain of parks
designed for Boston by
Frederick Law Olmsted,
groups nearly 15,000
specimen trees and
shrubs in a living botan-
ical museum on 265
acres. True to Olmsted's
prediction, the 1894
plantings took a full
century to mature.
Photo Robert Holmes

Founding Fathers

John Hancock's flourish on the Declaration of Independence may have secured his fame, but the Bay State Adams clan played a larger role in the birth of the country. Harvard-educated brewer Samuel Adams engineered the mass meeting that precipitated the Boston Tea Party, was among the Declaration's first signers, and, in 1788, secured the state's ratification of the U.S. Constitution—a document he earlier opposed as insufficiently radical. Never successful in business, he served as mayor of Boston and governor of Massachusetts.

Possessed of a cooler head, Sam's cousin John went farther. He served two terms as vice president under Washington and co-founded the Federalist Party. Our second president, he lost his reelection bid to his vice president, Thomas Jefferson. His son, John Quincy Adams, spent a life in public service and became the sixth president in 1824—also for one term. After losing to Andrew Jackson, John Quincy Adams embarked on his most influential years as a lawyer and congressman fighting against slavery.

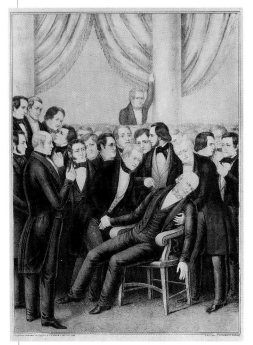

John Quincy Adams suffered a fatal stroke in the House of Representatives in 1848. He had returned to the House after his presidency. *National Portrait Gallery, Smithsonian Institution/ Art Resource*

"I long to hear that you have declared an independency.

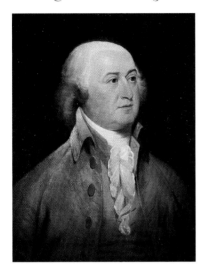

And, by the way, in the new code of laws which I suppose it will be necessary for you to make, I desire you would remember the ladies and be more generous and favorable to them than your ancestors. Do not put such unlimited power into the hands of the husbands. Remember, all men would be tyrants if they could. If particular care and attention is not paid to the ladies, we are determined to foment a rebellion, and will not hold ourselves bound by any laws in which we have no voice or representation...."

Abigail Adams, in a 1775 letter to her husband, John Adams

Above: John Adams by John Trumbull, 1793. *National Portrait Gallery, Smithsonian Institution/Art Resource* Adams, who authored the state's constitution, modestly described it as "Locke, Sidney, and Rousseau ... reduced to practice."

Right: Sam Adams's visage (on Paul Revere's body!) can be found on every bottle of his namesake lager made by the Boston Brewing Company, as well as their specialty brews like this Cranberry Lambic. *Boston Brewing Company*

"All politics is local."

Congressman Thomas P. "Tip" O'Neill

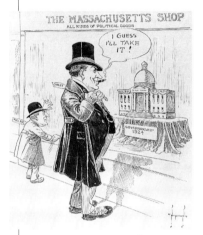

Above: A 1924 cartoon of gubernatorial candidate James Michael Curley. *Boston Public Library. Opposite above:* Tip O'Neill, photograph by Annie Leibovitz. *Contact Press Images. Opposite below:* John F. Kennedy and Attorney General Robert F. Kennedy confer during the Mississippi school desegregation crisis, 1962. *Photo UPI/Corbis-Bettmann*

The Irish Ascendancy

An Irish ethnic block seized the Massachusetts Democratic Party in the 1880s. Expanding from a base in Boston's immigrant wards, the underdog Irish came to dominate state government and, ultimately, most of Massachusetts' seats in Congress. Beginning with John F. "Honey Fitz" Fitzgerald—Boston mayor, state representative, congressman, and grandfather of John F. Kennedy—the state's Irish Democrats have produced colorful and influential figures. Few have been such rogues as James Michael Curley, who unseated Honey Fitz as mayor of Boston in 1914 and won his last election in 1945 while under federal indictment for mail fraud.

In 1948, Congressman and House Majority Leader John W. McCormack welcomed John F. Kennedy as his newest colleague in the Massachusetts delegation. When Kennedy moved on to the Senate in 1952, his seat went to Thomas P. "Tip" O'Neill, who, like McCormack, eventually rose to serve as Speaker of the House. JFK defined a new breed of Irish-American politician—dynamic yet polished enough to transcend ethnic biases and win election as the 31st president, the first Roman Catholic to hold that office. His brother, the often controversial Edward M. "Ted" Kennedy, has represented Massachusetts in the U.S. Senate since 1962.

"JACK KENNEDY, OF COURSE, WAS A Democrat. But...I'd have to say that he was only nominally a Democrat. He was a Kennedy, which was more than a family affiliation. It quickly developed into an entire political party, with its own people, its own approach, and its own strategies."

Tip O'Neill, Man of the House: The Life and Political Memoirs of Speaker Tip O'Neill, *1987*

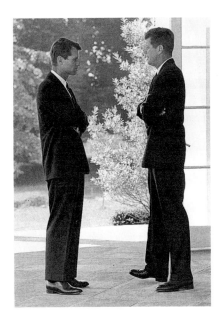

"FOR OF THOSE TO WHOM MUCH IS given, much is required. And when at some future date the high court of history sits in judgment on each of us, recording whether in our brief span of service we fulfilled our responsibilities to the state, our success or failure... will be measured by the answers to four questions: First, were we truly men of courage...Second, were we truly men of judgment...Third, were we truly men of integrity...Finally, were we truly men of dedication?"

President John F. Kennedy, speech to the Massachusetts State Legislature, January 1961

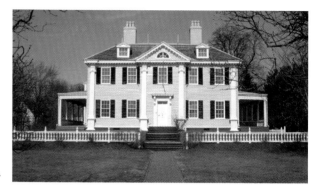

Right: The Georgian home of poet Henry Wadsworth Longfellow in Cambridge was built in 1759 and the side porches were probably added in 1793. Two-story pilasters provide decorative effect. The center gable, hipped roof and symmetrical twin chimneys are hallmarks of Georgian style.
Photo Philippa Lewis; Edifice/Corbis

Home-Grown House Styles

Two enduring American house styles—one formal and impressive, the other colloquial—originated in Massachusetts. The Cape Cod, an English workman's cottage locally adapted to sandy soils and strong winds, was first built in the late 17th

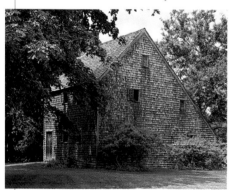

century as a one-story structure with lean-to, hugging the earth over an unfinished cellar. The first "capes" generally had unpainted shingle roofs and sides and clapboard fronts that weathered silver in the salt air. Several variations evolved: the "full cape" had a central chimney, while the smaller "half cape" was built with the chimney at one end to allow for later expansion.

The more formal Georgian Colonial style arose in the wealthy trading

Street in Ipswich by Gertrude Beals Bourne, 1918. Settled in 1637, Ipswich enjoyed a brief period of prosperity in the 18th century as a lacemaking center. Situated along a network of tidal estuaries, Ipswich is famous for the quality and quantity of its soft-shell clams. *Peabody Essex Museum. Photo Mark Sexton. Opposite below:* The Hoxie House in Sandwich, Cape Cod, built in 1637, is probably the oldest house still standing in Massachusetts. The classic "salt box" originally had a lean-to on the north side, creating a profile like the wooden boxes in which salt was once sold. *Photo Robert Holmes*

ports of Boston, Salem, and Marblehead in frank imitation of English mansions. Large, boxy, and possessed of showy windows and massive doors, the Massachusetts Georgian Colonial was widely imitated along the eastern seaboard. Ironically, the best "Georgian Colonial" homes in Massachusetts date from the Federal period (1790–1830) and were the work of architects Charles Bulfinch and Asher Benjamin (throughout Beacon Hill in Boston) and Samuel McIntire (Chestnut and Essex Streets in Salem).

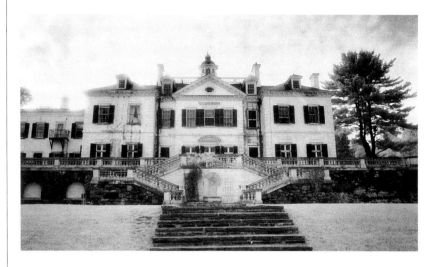

Cottages to Visit

The Mount
413-637-1899

Chesterwood
Home and studio of sculptor
Daniel Chester French in
Stockbridge 413-298-3579

Naumkeag
Stanford White–designed 1886
home with period furnishings
in Stockbridge 413-298-3239

Blantyre and Wheatleigh
Two opulent Lenox "cottages"
converted to luxury inns
Blantyre: 413-637-3556;
Wheatleigh: 413-637-0610

When English settlers spread into the Housatonic Valley in the Berkshire Hills in the mid-18th century, they built practical, low-ceilinged, wood-framed boxes typical of Massachusetts farms. A century later the robber barons of the Gilded Age discovered the pleasures of rusticating in the Berkshires, especially during the September and October foliage season. They made imperial architecture their hallmark by constructing more than 100 "cottages" in Lenox and Stockbridge between 1860 and 1910.

Based on Old World models as varied as the

Georgian country house and the Italian villa, many "cottages" featured what Cleveland Amory called "the peaks and turrets of outrageous fortune." One of the sanest—combining opulence with grace—was The Mount, the Lenox estate built in 1901–2 by Edith Wharton as a practical demonstration of the principles in *The Decoration of Houses,* the bible of interior decorating she authored with architect Ogden Codman, Jr., in 1897. Modeled after an English country manor with a French-style courtyard and an Italianate terrace, The Mount featured white stucco walls and green shutters— Wharton's nod to indigenous New England style. ✸

Above: Gazebo at Peirson Place, now an inn in Richmond. *Left:* Nook of the terrace at Chesterwood. *Opposite:* The Mount exemplified the principles Edith Wharton enunciated in *The Decoration of Houses:* "If proportion is the good breeding of architecture, symmetry, or the answering of one part to another, may be defined as the sanity of decoration." *All photos Joshua Green*

COLONIAL CRAFTERS

The cramped ships bringing colonists to Massachusetts had little room for furnishings, so carpenters and joiners soon turned their hands to furniture. The earliest recorded furniture maker was Plymouth's John Alden (whom Miles Standish foolishly sent to court Priscilla Mullins on his behalf). Decorative rather than purely functional cabinetry began to appear between 1680 and 1700 in the form of elaborately carved chests from Ipswich on the coast and Hadley in the Connecticut River Valley. Bay State cabinetry entered a golden age between 1760 and 1830, as wealthy shipping merchants commissioned fine furniture to fill their grand new homes. Cabinetmakers often created their best pieces from South American mahogany brought back on their patrons' ships. During the same period, the Willard family of central and eastern Massachusetts revolutionized clockmaking. ✪

Left: Queen Anne high chest of drawers in walnut veneer, c. 1730–50. Boston and Salem evolved as New England's leading centers for fine furniture in the English style. *Christie's Images. Above:* Lacy frosted glass goblet in the Tree of Life pattern by the Boston & Sandwich Glass Co., c. 1860s. *Photo Joshua Green*

Silver and Glass

Boston was the colonies' first silver-smithing center, home of America's most famed smith: Paul Revere. Son of a Huguenot silversmith, Revere produced some of the finest bowls and pitchers of the late 18th century, with an exquisite engraved line and light hammer touch.

Another flourish of achievement in the industrial arts took place after the colony became a state. In Sandwich, the oldest town on Cape Cod, famous colored glass was produced by a secret formula (now lost) from 1825 to 1888. America's first pressed glass and lace glass were made here; a fine collection can be seen at the Sandwich Glass Museum.

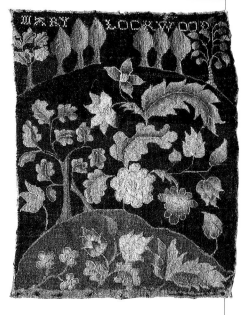

Left: Silver tankards by Paul Revere, c. 1768. Along with decorative items, Revere also made silver dental plates that he advertised as "of real Use in Speaking and Eating." *Winterthur Museum Above:* Sampler by Mary Lockwood, c. 1785. The American sampler did not begin to evolve a decorative vocabulary separate from English samplers until the early 19th century. Floral and leaf patterns such as this example were often designed as practice samplers to teach young women of genteel upbringing the needlework with which they would later mark their family linens. *America Hurrah Archive, New York*

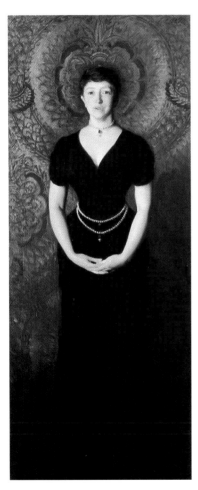

Socialite Isabella Stewart Gardner (1840–1924) created one of America's great private art troves. Aided by scholar Bernard Berenson, she assembled the core of the collection between 1894 and 1903, spending more than $1 million to capture such masterpieces as Titian's *Rape of Europa,* Botticelli's *Lucretia,* a Rembrandt self-portrait, and the first Raphael in America. Nor did she neglect the moderns, later becoming the first American to own a Matisse and acquiring many works by John Singer Sargent and James McNeill Whistler. With a collection eventually reaching some 2,500 objects spanning 30 centuries, Gardner built a Venetian-style palazzo, Fenway Court, in Boston and placed each object to suit her taste. Gardner opened Fenway Court for public viewing—as well as for concerts and theatrical performances—frequently between 1903 and her death in 1924.

Fenway Court was converted to a museum in 1925 with the stipulation

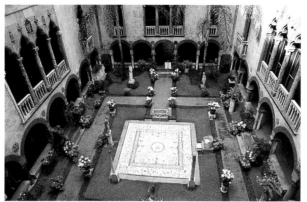

Left: Courtyard of the Isabella Stewart Gardner Museum. *Photo Paula Lerner. Below: Diana,* bronze statue by Paul Manship, 1921. *Opposite: Isabella Stewart Gardner* by John Singer Sargent, 1888. When this telling portrait was exhibited in 1888, it was deemed so scandalous that it remained in storage until after the socialite's husband died. *All, Isabella Stewart Gardner Museum*

that everything be left as Gardner had placed it. As a result, blank spots mark where 13 works of art (conservatively valued at $200 million in today's art market) were snatched on March 18, 1990, in the world's largest art theft to date. Still, Gardner's psyche continues to rule the rooms. ◉

"YEARS AGO I DECIDED THAT THE GREATEST NEED IN our Country was Art. We were largely developing the other sides. We were a very young country & had very few opportunities for seeing beautiful things, works of art....So I determined to make it my life work if I could."

Isabella Stewart Gardner in a 1917 letter to a friend

Art in the Kitchen

Early Bay State recipes might be characterized as 101 ways to use up leftover cod. Modern cookery arrived when Fannie Eugene Merritt Farmer (1857–1915) burst on the scene with her Boston Cooking School. The first teacher to emphasize nutrition and advocate exact measurements, Farmer had to finance the first edition of the *Boston Cooking-School Cook Book* in 1896 because it was considered a risky proposition. After more than a century, the *Fannie Farmer Cookbook* remains a staple in bookstores and kitchens.

Three generations later, Julia Child of Cambridge freed Americans from cooking by rote, making the art of classic cuisine joyously accessible. In 1961, she coauthored *Mastering the Art of French Cooking*, the first of many best-selling volumes. Beginning with *The French Chef*

Above: Basket of soft-shell clams. *Photo Catherine Karnow/Corbis Right:* The classic boiled lobster dinner. *Photo Michael Skott. Opposite above:* Maple syrup label. Boston manufacturers routinely extended maple syrup from New England with West Indian cane syrup. *Private collection. Opposite below:* Julia Child. *Photo Nora Feller/Outline*

in 1962, she crossed over into public television, winning a Peabody, an Emmy, and widespread public adulation. Child has been hailed on the cover of *Time* and lovingly satirized on *Saturday Night Live*. The proponent of all things in moderation, she pronounced in her 84th year, "I am the best example of my lifestyle."

The ultimate proof that Massachusetts takes cooking seriously is the Schlesinger Library on the History of Women in America at Radcliffe College, which houses an exhaustive cookbook collection.

"YOU HAVE TO PROJECT BACK 35 YEARS. YOU COULDN'T buy a garlic press in Boston. Markets didn't carry leeks. Do you know what they were serving at the Ritz-Carlton? Codfish cakes and baked beans! People could boil eggs or scramble them, but that was it. So, when Julia cooked an omelet, people were dazzled."

Russell Morash, producer of The French Chef, *quoted in the* Boston Globe, *March 6, 1997*

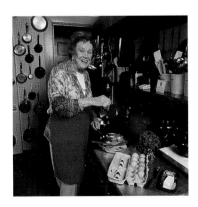

Wellfleet Oysters with Hard-Cider Mignonette

Bob Sargent, chef at several fine Boston restaurants, devised this recipe, published in the July 9, 1997 *Boston Globe.*

1 cup hard cider
2 tbsp. Champagne vinegar
2 tbsp. finely chopped shallots
2 tbsp. finely chopped Granny Smith apple
½ tsp. freshly ground black pepper
3 dozen Wellfleet oysters, shucked

Place cider in a saucepan and bring to a boil. Reduce to ¼ cup. Remove from heat and set aside to cool. Stir in vinegar, shallots, apple, and black pepper. Place shucked oysters on a serving platter. Spoon ½ tsp. sauce over each and serve at once. Serves 6.

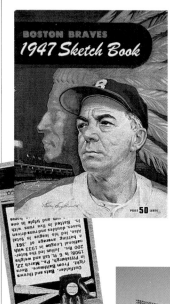

The Old Ball Game

Bay Staters reconcile their Puritan origins with their deep attachment to sports by rooting for teams that always seem to lose the big games. The notable exception has been in basketball—a sport devised by Professor James Naismith in the winter of 1891 at Springfield College (then known as the School of Christian Workers). The Basketball Hall of Fame at Springfield recalls the origins. Roughly a half century after Naismith nailed up peach baskets in the school gym, the Boston Celtics began its winning dynasty as a team with 16 NBA championship flags in the rafters. Massachusetts also claims the invention of volleyball by William Morgan in 1895, in Holyoke.

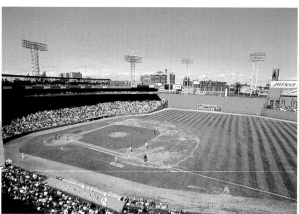

But Massachusetts character is better defined by the long-suffering Boston Red Sox fans, who have waited in vain for a World Series championship since 1918. (Some blame the drought on the "curse of the Bambino," the bad karma from selling Babe Ruth to the Yankees in 1920.) Red Sox baseball is played at "the emerald of baseball's diamonds," tiny Fenway Park, one of the two oldest parks in major league baseball. It opened on April 20, 1912, when the Red Sox beat the New York Highlanders (later renamed the Yankees) 7–6 in 11 innings. The mind-set of "Red Sox Nation" was summed up by a *Boston Globe* sportswriter in 1986: "A fatalistic gloom hangs over Boston. It is August and the Red Sox are in first place."

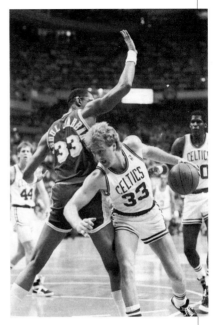

"FENWAY PARK, IN BOSTON, IS A LYRIC LITTLE BANDBOX of a ballpark. Everything is painted green and seems in curiously sharp focus, like the inside of an old-fashioned peeping-type Easter egg. It was built in 1912 and rebuilt in 1934, and offers, as do most Boston artifacts, a compromise between Man's Euclidean determinations and Nature's beguiling irregularities."

John Updike, "Hub Fans Bid Kid Adieu," 1960

The Celtics' great forward, Larry Bird, drives to the basket. *UPI/ Corbis-Bettmann.* Opposite left: Memorabilia from the Red Sox and the Boston Braves. The latter played in Boston from 1912–1952. *Courtesy Mark Macrae.* Opposite below: Fenway Park. *Photo David Madison*

Go to Jail. Go Directly to Jail.
Do Not Pass Go. Do Not Collect $200.

Monopoly Chance card

Known as "the man who taught Americans how to play," Milton Bradley formed his company in Springfield in 1860, capitalizing on high-quality lithography to publish some of America's earliest board games. One of his first efforts, "The Checkered Game of Life," proved a best-seller throughout the northeast. While Puritan New England frowned on games of chance, Bradley stressed the need for skill in his games. Bradley's company went on to introduce Americans to classic games from other countries, including backgammon, and its own creations included "Yahtzee" and the children's classic "Candy Land."

Another dedicated game aficionado was George S. Parker of Salem. In 1883, the 16-year-old Parker invested his life's savings of $50 in a game he had invented called "Banking." The gamble paid good interest: by 1888 the Parker Brothers (founder George and his sibling Charles) had 29 games (most dreamed up by George) to their credit. ✪

Left: "The Game of Favorite Art" by Parker Brothers, 1897. Below: "Clue" by Parker Brothers, 1949. Opposite above: "Dr. Quack" by the Russell Company, 1922. Opposite below: "Monopoly" by Parker Brothers, 1935. Massachusetts was a leader in high-quality color lithography, which helped spawn popular board and card games. All, collection of The Big Game Hunter. Photos Bruce Whitehill. "Monopoly®" and "Clue®" & © Hasbro, Inc.

Colonel Mustard, in the Library

Eventually, Parker Brothers became one of the world's largest game manufacturers, publishing more than 1,200 card and board games including "Pit," "Rook," "Risk," and "Clue." But George didn't invent the company's most famous game, "Monopoly." At the height of the Depression in 1935, Parker Brothers bought the "Monopoly" game rights from Charles Darrow and was soon making 20,000 sets a week. To date, the "Monopoly" game has been produced in 26 languages in 80 countries, as well as in hand-held electronic and CD-ROM versions.

Right: The House of the Seven Gables in Salem was once owned by a cousin of Nathaniel Hawthorne, who set his famous romance here. *Photo Kevin Fleming/ Corbis. Below: Nathaniel Hawthorne* by Emanuel Gottlieb Leutze, 1862. *National Portrait Gallery, Smithsonian Institution/ Art Resource*

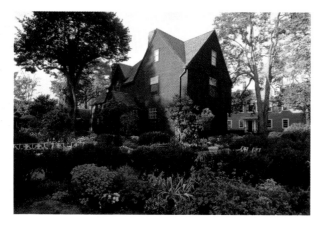

Massachusetts can boast both the first printing press in the American colonies (Cambridge, 1640) and the first literary book (Anne Bradstreet's poems, 1650). Nearly two centuries later, the writers of Boston and Concord forged a truly American literature and dominated national letters for three generations. The so-called American Renaissance began in 1836 with the publication of Ralph Waldo Emerson's *Nature,* a book of essays that replaced the gloom and doom of Puritan theology with the sunny optimism of Transcendentalism. Concord became a literary and social hotbed as creative thinkers coalesced around

Emerson, including the utopian dreamer Bronson Alcott (whose daughter Louisa May achieved greater fame) and America's first professional writer, Nathaniel Hawthorne. Although he lived 100 miles west, Herman Melville was drawn into Emerson's orbit through their mutual friend Hawthorne. But Emerson's most devoted protégé was Henry David Thoreau. The high-water mark of the Transcendentalist movement might be 1850–55, when three American classics were published: Hawthorne's *Scarlet Letter*, Melville's *Moby-Dick*, and Thoreau's *Walden*. ✦

"ALL THE GREAT LITERARY FIGURES OF the American Renaissance except the New Yorker Walt Whitman and the southerner Edgar Allen Poe were grandchildren of men who had served with Paul Revere or soldiered at Lexington or Concord."

David Hackett Fischer, Paul Revere's Ride, *1994*

Left: Illustration by Howard Pyle for the picture book *Yankee Doodle,* a retelling of the old song, 1881. *Above:* Ralph Waldo Emerson presided over the birth of American thought. His essay The "American Scholar" was a landmark. Photograph by George K. Warren, c. 1860s. *National Portrait Gallery, Smithsonian Institution*

Right: The February 1950 cover of *The Atlantic* was an Al Capp illustration of Charlie Chaplin. *The Atlantic Monthly. Below:* Illustration by Jessie Willcox Smith from Louisa May Alcott's *Little Women,* c. early 1900s. Because her father, A. Bronson Alcott, had no head for money, Louisa May supported the entire family on her literary earnings, including adventure tales she wrote under pseudonyms. *The Granger Collection*

The Flowering of New England

Through the 1840s and 50s, Boston became the center of American literary publishing, with the birth of both Little Brown and Ticknor & Fields (now Houghton Mifflin) and of many literary reviews, including *The Dial, The North American Review,* and *The Atlantic Monthly.* The city established the first free urban public library in

1852. More mainstream writers than the Transcendentalists held forth in Boston: Henry Wadsworth Longfellow of *Hiawatha* fame (it made his fortune), Oliver Wendell Holmes *(The Autocrat of the Breakfast Table),* and James Russell Lowell, a poet now forgotten but second only to Emerson as a literary

lion in 19th-century America. Boston was the seat of American literature, and its oligarchs were the members of the Saturday Club—Emerson, Lowell, Holmes, Longfellow, John Greenleaf Whittier, and publisher Jamie Fields—who met for dinner each week at the Parker House and entertained visiting literati such as Charles Dickens.

> Build thee more stately mansions,
> O my soul,
> As the swift seasons roll!
>
> *Oliver Wendell Holmes,*
> *"The Chambered Nautilus," 1858*

"It is a great art to saunter."

Henry David Thoreau, Journal, April 26, 1841

In Thoreau Country

Henry David Thoreau, America's enduring literary individualist, was born in 1817 in Concord, where he spent nearly his entire life. After graduating from Harvard College in 1837, he taught school for a few years, worked off and on at his father's pencil-making factory, and did a little surveying. He also spent much time at Ralph Waldo Emerson's home, where he was a frequent babysitter, before living two years in a cabin on Walden Pond on land owned by Emerson. His book about the experience, *Walden; Or, Life in the Woods* (1854), made his name if not his fortune and remains, with his essay "On Civil Disobedience," the cornerstone of his literary legacy. Variously claimed as the first beatnik, a proto-Buddhist sage, and a libertarian prophet, Thoreau was his own man—cranky, irascible, original.

Above: Thoreau in Cattails, wood engraving by Michael McCurdy from *The Wingéd Life,* 1985. McCurdy is a leader among the bookmaking artists carrying on Rockwell Kent's revival of woodcut and wood engraving techniques. *Left:* Thoreau's cabin at Walden Pond, as depicted on the title page of an 1875 edition of *Walden. The Granger Collection, New York*

WALDEN.

BY HENRY D THOREAU,

AUTHOR OF "A WEEK ON THE CONCORD AND MERRIMACK RIVERS."

I do not propose to write an ode to dejection, but to brag as lustily as chanticleer in the morning, standing on his roost, if only to wake my neighbors up.—Page 92.

"I WENT TO THE WOODS BECAUSE I wished to live deliberately, to front only the essential facts of life, and see if I could not learn what it had to teach, and not, when I came to die, discover that I had not lived."

Henry David Thoreau, Walden, 1854

*There is no Frigate like a Book
To take us Lands away...*

Emily Dickinson

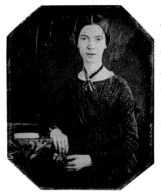

Many a poet has taken the state's measure, beginning with Anne Bradstreet, the first poet writing in English in the New World. Phillis Wheatley made her mark with the first volume of poems by an African American (1778). In many ways the 19th century was the golden age of Bay State verse, dominated by men with three names: the high rhetoric of William Cullen Bryant ("Thanatopsis"); the didactic, often amusing poems of Oliver Wendell Holmes ("Old Ironsides," "The Chambered Nautilus"); the epic outpourings of Henry Wadsworth Longfellow; and the neoclassical lines of James Russell Lowell and John Greenleaf Whittier ("Snowbound"). Emily Dickinson, the state's greatest 19th-century poet, held conversations with her soul in Amherst, unnoticed until after her death. ☉

How dreary—to be—Somebody!
How public—like a Frog—
To tell one's name—the livelong June—
To an admiring bog!

Emily Dickinson, No. 288, c. 1861

Massachusetts Moderns

In the 20th century, the Lowell family kept remaking American poetry. Amy Lowell introduced America to free verse, while her distant cousin Robert Lowell shocked many when he abandoned formal verse for prose poetry in *Life Studies*. One of our most influential experimental poets, e. e. cummings, was born and educated in Cambridge. Bay State colleges and universities have also attracted many major figures, including Archibald MacLeish, U.S. poets laureate Richard Wilbur and Robert Pinsky, and Nobel laureate Derek Walcott.

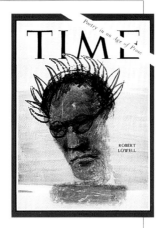

Only teaching on Tuesdays, bookworming
in pajamas fresh from the washer each morning,
I hog a whole house on Boston's
"hardly passionate Marlborough Street."

Robert Lowell, "Memories of West Street and Lepke," 1959

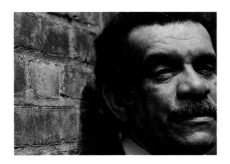

Above: Robert Lowell by Sidney Nolan. Time *magazine cover art, 1967.* Time, Inc. *Below: Nobel laureate Derek Walcott, born in St. Lucia, makes his home in Boston. Photo Eugene Richards/Magnum Photos, Inc. Opposite above: Emily Dickinson at age 17, the only known image of the poet. Amherst College Library. Opposite below: Henry Wadsworth Longfellow by Theodore Wust, c. 1870s. Longfellow grew his beard to cover scars suffered in a fire that killed his wife. National Portrait Gallery, Smithsonian Institution/Art Resource*

Right: In 1915, a group of New York bohemians began presenting plays in Provincetown. A converted fish house became the site of many Eugene O'Neill premieres; the Provincetown Players also included John Reed and Louise Bryant. Here, O'Neill (on ladder) and friends hang scenery for the playwright's *Bound East for Cardiff, 1916. Below:* The Old Boston Theatre on Federal Street, cigar box card by P. Lorillard, c. early 1900s. *Both, Museum of the City of New York Opposite:* Matt Damon and Robin Williams in *Good Will Hunting. Photofest*

On the Boards

Flouting its Puritan heritage, Boston gave birth to both vaudeville and burlesque. In the 1880s, B. F. Keith began pro-

ducing "wholesome entertainment" variety shows, which ultimately toured the country as "vaudeville." The nearby Howard Atheneum added comely ladies in skin-tight costumes to its shows; when the costumes came off, burlesque was born. Partly in response, in 1905 the city banned "all forms of muscle dancing" and women "appearing on the stage with legs bare."

By the 1920s, the Berkshires had become a hotbed of summer theater and Boston a key tryout

town for Broadway-bound productions. Audiences and critics took pride in providing sophisticated feedback. Rodgers and Hammerstein tuned up all their musicals in Boston, writing two new songs for *The King and I* in a Ritz-Carlton Hotel suite. (Rodgers and Lorenz Hart had composed "Ten Cents a Dance" at the hotel years earlier.) Tennessee Williams's first two plays died in Boston in the 1940s, and his third, *A Streetcar Named Desire* (starring Jessica Tandy and newcomer Marlon Brando), spent two weeks in rewrites at the Wilbur Theatre. A cumbersome show called *Away We Go!* arrived at the Shubert in 1943, spent weeks in frenzied rewrites, and sped to New York as the groundbreaking *Oklahoma!*

Banned in Boston

Official city censorship of the stage began in 1750, and until *Equus,* with its nudity and erotic subplot, laid it to rest in 1975, producers often bolstered a play's commercial

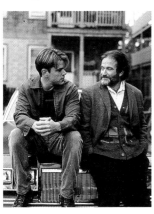

prospects by letting it be "Banned in Boston!" In 1929, Eugene O'Neill's Pulitzer Prize–winning *Strange Interlude,* a drama of a woman's quest for fulfillment, was damned by Boston clerics as "drenched with sex and written to point out the futility of religion"—and it played to packed houses in neighboring Quincy.

Massachusetts on Film

Good Will Hunting Blue-collar genius from South Boston accepts his talents and wins Harvard girl

The Crucible Arthur Miller's political parable based on Salem witch trials

Little Women Louisa May Alcott classic, shot in Concord

Mermaids Cher as saucy single mother finds love with Bob Hoskins

Glory Inspiring Civil War tale of all-black 54th Massachusetts Regiment

The Witches of Eastwick John Updike's fantasy of three New England women who conjure up the devil

The Bostonians Vanessa Redgrave stars in adaptation of Henry James novel

The Verdict Washed-up Boston lawyer (Paul Newman) wins a big case

Jaws Monster shark terrorizes island beach resort

The Friends of Eddie Coyle Gritty evocation of Boston underworld

Love Story Boy meets girl at Harvard. Girl dies. Audiences weep.

Right: Sheet music for *Bunker Hill Grand Centennial March* by L. Mason. *The Bostonian Society/ Old State House. Below:* Leonard Bernstein leads the Vienna Philharmonic in rehearsal. Bernstein grew up in Boston and its suburbs and attended Harvard before embarking on his conducting and composing career. He taught yearly at the Tanglewood Summer Institute in the Berkshires. *Photo Ron Scherl/ StageImage*

Boston is a world center for the performance of medieval, baroque, classical, and modern orchestral music. The tradition began in 1815 with the founding of the Handel & Haydn Society, which produced the American premieres of Handel's *Messiah,* Bach's *B-Minor Mass,* and Verdi's *Requiem,* and continues an active concert season. Much of Boston's musical activity centers on the New England Conservatory of Music, founded in 1867, and the Boston Symphony Orchestra (1881). In July 1885,

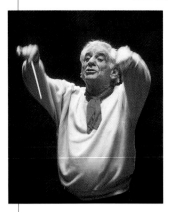

the symphony gave its first "Promenade" concert of popular music, a series soon renamed "Pops." Free Pops concerts on the Charles River Esplanade began under the baton of Arthur Fiedler in 1929 and continue annually. The BSO took up summer residence at Tanglewood in the Berkshires in 1937, founding a training school for musicians there in 1940.

Both early and contemporary orchestral music are well represented in Boston. The biennial Boston Early Music Festival is among the

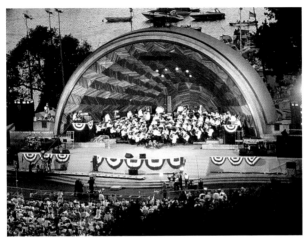

Left: The Boston Pops Esplanade Orchestra performs at the Hatch Shell on Boston's Charles River Esplanade. *Photo Miro Vintoniv. Below:* The Tanglewood Music Center Orchestra performs at Seiji Ozawa Hall. Designed by William Shawn, the hall opened in 1994. *Photo Steve Rosenthal. Both, courtesy Boston Symphony Orchestra*

world's most prestigious, while Boston Camerata presents early music on period instruments. Boston Musica Viva, established in 1969, performs only 20th-century music, premiering new works at most concerts. The ensemble has championed many composers who later won Pulitzer Prizes, including John Harbison and Ellen Taaffe Zwilich. ☉

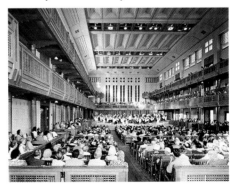

Gotta Sing

Massachusetts can carry a popular tune as well, with Boston and the Pioneer Valley serving as incubators for new talent and friendly venues for established musicians. Boston's Berklee College of Music, the world's largest independent music college, boasts among its alumni producer/arranger Quincy Jones, "Tonight Show" band leader Kevin Eubanks, film composer Alan Silvestri, jazzman Branford Marsalis, and singer/songwriter Paula Cole. The Afro-American

Music and Jazz program at the University of Massachusetts–Amherst focuses on what professor Max Roach calls "African-American classical music." A parallel scene in acoustic music thrives in both the Pioneer Valley and the Boston area, where Cambridge's legendary Club Passim launched the careers of such singer/songwriters as Suzanne Vega, Tracy Chapman, and Shawn Colvin. Cambridge's Rounder Records is America's largest producer of roots and roots-oriented recordings.

Left: Percussionist Max Roach asserts that "jazz" should really be termed "African-American classical music." *Photo Herman Leonard/StageImage. Right:* Tracy Chapman got her start as a Harvard Square street singer before going on to pop stardom. *Photo Pat Johnson/StageImage. Above:* CD cover art for Rounder Records artist Michelle Willson, 1994.

Left: A performance on the Inside/Out stage at Jacob's Pillow. *Photo Skip Brown/Jacob's Pillow Below:* Legendary dancer Ted Shawn. The Ted Shawn Theatre at Jacob's Pillow in Becket opened in 1942 as the first theater in the United States designed specifically for dance. *San Francisco Performing Arts Museum and Library*

Gotta Dance

The woodsy mountaintop retreat of Jacob's Pillow in Becket is legendary in the world of modern dance. Here in 1933 Ted Shawn and His Men Dancers developed an athletic style of dance that built on Shawn's expressive work with his wife, Ruth St. Denis, in the Denishawn Dance Company. After World War II, the summer festival at "the Pillow" became the premier national showcase for modern dance in a dizzying array of styles from cerebral performance art, to the athleticism of the Pilobolus Dance Theatre, to ethnic dance, to the theatrical tableaux of the Mark Morris Company. In addition to major dance concerts in the Ted Shawn Theatre, the Pillow presents works in progress by new and emerging choreographers on its wooded outdoor stage.

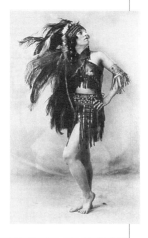

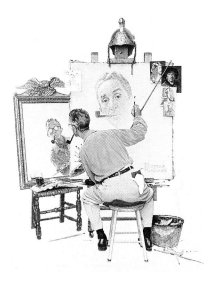

A merica's most beloved popular illustrator and master of the anecdotal scene, Norman Rockwell was born in 1894 in New York but spent his last 25 years living and working in Stockbridge, Massachusetts—a town he called "the best of America, the best of New England."

Rockwell aspired from an early age to be an illustrator and left school at 15 to study at the National Academy of Design and the Art Students League. He was only 22 when he executed his first cover for the

Above: Triple Self-Portrait by Norman Rockwell, 1960. Note Rockwell's none-too-subtle reference to Rembrandt's self-portrait pinned to the easel. *Right: Stockbridge Main Street at Christmas* by Norman Rockwell, 1967. Rockwell's first studio was in the brick building, third from left. *Both, The Norman Rockwell Family Trust*

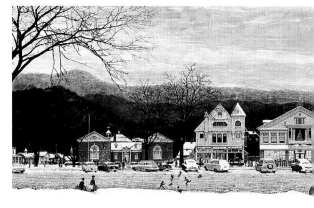

Saturday Evening Post. Over nearly half a century, he painted 321 *Post* covers that delineated a reassuring vision of small-town life in a century of disorienting change. His domestic dramas chronicled the introduction of the telephone, radio, electrical light, TV, air travel, and space flight. Later, Rockwell addressed such social themes as civil rights and poverty; he died in 1978.

Rockwell never apologized for his optimistic vision. "I paint life as I would like it to be," he said. "Somebody once said that I paint the kind of girls your mother would want you to marry." ⊛

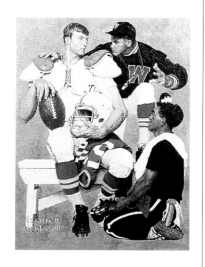

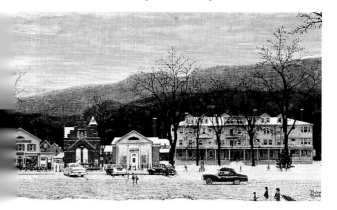

Above: The Recruit by Norman Rockwell, 1966. Rockwell used friends and neighbors as models for his illustrations. As he noted in his autobiography, "Every time I go to town meeting or some other public affair, I fairly drool over the models I have so far missed." *The Norman Rockwell Family Trust and the Norman Rockwell Museum at Stockbridge*

With two of the nation's well-regarded visual arts colleges—the Massachusetts College of Art and the School of the Museum of Fine Arts—the Bay State experiences an annual influx of fresh talent in the traditional visual arts and all the permutations of mixed media. At the same time, light and geography in places like Cape Ann and Cape Cod continue to inspire both landscape and abstract painters. Several museums display and collect the work of Massachusetts and New England artists, including the Fitchburg Art Museum and the DeCordova Museum in Lincoln, which places contemporary sculpture throughout its grounds.

Left: The Lantern by Paul Resika, 1996. Collection Jim and Susan Hill Salander-O'Reilly Galleries, New York. Below: Camera Obscura Image of Boston View Looking Southeast in Conference Room by Abelardo Morell, 1998. Courtesy the artist and Bonnie Benrubi Gallery. Opposite above: Grotto by Michael Mazur, 1998. Barbara Krakow Gallery. Opposite below: Norman Rockwell Meets Christo on Main Street by Libby Barker, 1997. Norman Rockwell Museum, Stockbridge

While the galleries of Boston's Newbury Street and the art colony towns of Rockport and Provincetown remain the best places to see contemporary painting, some of the most exciting new work in multimedia and mixed media emanates from artists' studios concentrated in urban neighborhoods.

Hive by Michael James, 1998. Studio quilt of hand-painted and commercial cotton fabrics. A pioneer in the studio quilt movement, James straddles the disparate worlds of fine craft and fine art and remains the movement's leading practitioner of abstract composition. *Courtesy the artist. Photo David Caras*

The Fuller Museum in Brockton has an outstanding collection of contemporary art in craft media, an area in which the state is particularly rich. In fact, the term "studio furniture" was first applied to contemporary work at the Museum of Fine Arts, and Massachusetts is considered one of the leading states in this movement. Bay State artists also rank high in the field of contemporary photography, with work ranging from the documentary to the abstract. The Massachusetts College of Art houses one of only five Polaroid 20 x 24 cameras

in the world. Dozens of "code artists," meanwhile, are creating work in digital media that completely blurs distinctions between visual and performing arts and is typically displayed either online or in CD format. At the other end of the spectrum from art that employs advanced technology, the Pioneer Valley of western Massachusetts remains a center of fine bookmaking and illustration. ⊛

Above: Columbine by Olivia Parker, 1991. Polacolor photograph. *Courtesy the artist and the Polaroid Collection Left: Monkey Settee* by Judy Kensley McKie, 1994. McKie's whimsical yet refined studio furniture is represented in the collections of the Smithsonian and the ARC Union in Paris. *Clark Gallery and Gallery NAGA*

Everlasting Bouquets

Harvard University's Botanical Museum is a favorite place for locals to take visiting great-aunts, if only to see the Ware Collection of Glass Models of Plants—better known as the "Glass Flowers." Some 3,000 scientifically accurate life-sized models and magnified plant parts were created by Leopold and Rudolf Blaschka between 1887 and 1936.

When Knights Were Bold

John Woodman Higgins, proprietor of Worcester Pressed Steel, once wrote to a friend that he longed "for one good suit" of armor. He ended up collecting more than 100 from medieval and Renaissance Europe, feudal Japan, and ancient Greece and Rome. His Higgins Armory Museum in Worcester is America's only museum dedicated to arms and armor.

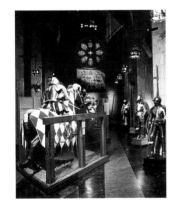

Stained-Glass Window on the World

The Mapparium, a stained-glass globe at the Christian Science Publishing Society, is a unique representation of the planet. From a 30-foot glass bridge that passes through the center, visitors see the land and water areas of the earth in correct proportion and relationship. Political boundaries are set to 1932–35, when the globe was created.

Follow the Leda

Fifteen-minute swan boat cruises on the lagoon of the Public Garden have been a Boston tradition since 1877, when Roger Paget introduced the fanciful vessels powered by foot pedals. Paget's design was inspired by sets from Richard Wagner's popular opera, *Lohengrin.* His descendents still operate the concession, which persists as the city's giddiest flight of Victoriana.

The Not-So-Micro Processor

Housed at Boston's Computer Museum, the Walk-Through Computer reverses the trend toward miniaturization. It's literally the size of a two-story house, and it is

updated every few years with the latest and speediest microprocessor in macro scale. It's said to be the largest personal computer in the world.

Road Warriors

America's first production motorcycle marque, the Indian, was based in Springfield. Although the factory closed in 1953, a few diehards keep their old Indians on the road. The Springfield Indian Motorcycle Museum and Hall of Fame proudly displays every model of this legendary American conveyance.

Great People

A selective listing of native Bay Staters, concentrating on the arts.

Chick Corea (b. 1941), jazz pianist and composer

Horatio Alger, Jr. (1832–1899), author of more than 100 rags-to-riches novels

Fred Allen (1894–1956), comedian and early television personality

Susan B. Anthony (1820–1906), women's suffrage leader, abolitionist

Clara Barton (1821–1912), Civil War nurse and first director of American Red Cross

Leonard Bernstein (1918–1990), conductor and composer

John Cheever (1912–1982), novelist and short fiction writer

John Singleton Copley (1738–1815), portrait painter

Richard Henry Dana (1815–1882), author of *Two Years Before the Mast*

Bette Davis (1908–1989), Academy Award–winning actress

W. E. B. DuBois (1868–1963), civil rights leader, co-founder of NAACP, author of *The Souls of Black Folks*

Benjamin Franklin (1706–1790), statesman, scientist, inventor

Erle Stanley Gardner (1889–1970), author of Perry Mason mysteries

Theodor Seuss Geisel ("Dr. Seuss") (1904–1991), children's book author

Childe Hassam (1859–1935), Impressionist painter

Jack Kerouac (1922–1969), Beat novelist and poet, best known for *On the Road*

Maria Mitchell (1818–1889), astronomer, first woman elected to American Academy of Arts and Sciences

Leonard Nimoy (b. 1931), actor and author

Samuel Eliot Morison (1887–1976), historian

Robert Parker (b. 1932), author of Spenser mystery novels

Francis Parkman (1823–1893), historian of the frontier

Anne Sexton (1928–1974), Pulitzer Prize–winning poet

Louis Henri Sullivan (1856–1924), pioneer of modernism in architecture

James Taylor (b. 1948), folk and ballad singer/songwriter

Paul Theroux (b. 1941), novelist and travel writer

Barbara Walters (b. 1931), television reporter and celebrity interviewer

William Wegman (b. 1943), photographer

Dorothy West (1910–1998), novelist, member of the Harlem Renaissance

James Abbott McNeill Whistler (1834–1903), painter

...and Great Places

Some interesting derivations of Massachusetts place names.

Amherst Named for Lord Jeffrey Amherst, a British general in the French and Indian Wars.

Athol Named by John Murray, son of the Scottish Duke of Atholl, because scenery reminded him of his ancestral home.

Bash Bish Falls Named for Indian maiden who, legend says, died going over falls in her canoe while fleeing white trappers.

Bearskin Neck Named for bear captured when it was stranded by the tide on this Rockport promontory.

Lake Chargoggagoggman-chauggagoggchaubnuna-gungamaug The longest, most complex name in U.S. geography is Nipmuck for "you fish on your side, I fish on my side, no one fishes in the middle." Some mapmakers give up and call it Lake Webster.

Lake Quinsigamond Algonquian for "place of long fishes."

Money Brook Falls Waterfall on Mount Greylock named for a nearby cave, where Pine Tree

shillings were supposedly counterfeited during colonial period.

Monterey Named for American victory in the Mexican War.

Mount Grace Named for baby who died and was buried at the foot of this mountain while her mother was forcibly marched to Canada by Indian captors.

Orleans After Louis Philippe, Duke of Orleans, who visited New England in 1797.

Peru Highest altitude village in state, named for the mountainous South American country.

Teaticket From Wampanoag word for "main course of the tidal river."

Ware Nipmucks called the site Nenameseck, meaning "fishing weir."

Wayland Named in 1835 for Francis Wayland, clergyman and president of Brown University, who helped establish first free library in Massachusetts.

White Horse Beach Legend says that in 1778 a young woman

rode a white horse into the ocean here and drowned because her physician father disapproved of her sailor lover.

Williamstown Formerly West Hoosac, renamed for General Ephraim Williams, who died in 1755 fighting the French and left a bequest to establish a college, provided the school and the town carry his name.

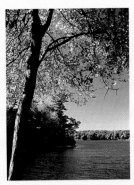

Concord Symbolizes pipe of peace smoked by Massachusett tribe that sold "six myles of land square" with the English settlers who bought it.

MASSACHUSETTS BY THE SEASONS
A Perennial Calendar of Events and Festivals

Here is a selective listing of events that take place each year in the months noted; we suggest calling ahead to local chambers of commerce for dates and details.

January

Boston
Chinese New Year
Depending on lunar calendar, falls late January to early March.

Sutton
Sleigh Rally
Competitors reproduce Currier & Ives with period costumes and antique sleighs. Sleigh rides.

February

Cambridge
Longfellow Birthday Celebration
Tours of Longfellow House, poetry readings, and wreath-laying at the poet's grave.

March

Boston
Boston Massacre Reenactment
Reenactment at Old State House of key pre-Revolution event.

New England Spring Flower Show
Five acres of landscaped gardens in oldest U.S. flower exhibition.

Northampton
Spring Bulb Show
More than 2,500 flowering bulbs at historic Lyman Plant House.

April

Boston
Annual Lantern Celebration
Commemorates role of lanterns in Revere's midnight ride.

Boston Marathon
America's oldest marathon.

Lexington and Concord
Battles of Lexington and Concord Reenactment

Nantucket Island
Daffodil Festival
To celebrate return of spring.

May

Boston
Ducklings Day Parade
Retraces route of ducklings in Robert McCloskey's children's book *Make Way for Ducklings*.

Hidden Gardens of Beacon Hill
Self-guided tour of gardens in premier Federal-era district.

Lilac Sunday
More than 250 lilac varieties in bloom at Arnold Arboretum, third Sunday in May.

Brimfield
Brimfield Antiques
One-mile strip features more than 1,000 antiques dealers. Repeats in July and September.

Sandwich
Dexter Rhododendron Festival
Heritage Plantation's famous rhododendrons at peak bloom.

June

Attleboro
Wollomonuppoag Indian Council Powwow
Dancing, music, traders, food, and storytelling.

Boston
Boston Globe Jazz Festival
Free outdoor performances and ticketed events.

Boston HarborFest
Celebrates maritime history of Boston with historic reenactments, chowderfest, concerts.

Dragon Boat Festival
Competitors race intricately painted and carved boats.

Italian Festivals
Feasts of Italian patron saints are celebrated with street fairs and processions June–August.

Charlestown
Bunker Hill Day Weekend
Battle of Bunker Hill is commemorated with drills, parade.

Nantucket
Nantucket Film Festival
Weeklong event focuses on the craft of screenwriting.

West Springfield
American Crafts Council Craft Fair
Juried exhibition at Eastern States Exposition.

July

Boston
Bastille Day Street Dance
Street festival with French food
and dance.

Boston Pops Fourth of July Concert
Part of a week of free Pops per-
formances.

Boylston
*Tower Hill Botanic Garden:
Lily Show*

East Falmouth
Barnstable County Fair
Celebrates farming roots of
Cape Cod.

New Bedford
Feast of the Blessed Sacrament
Largest Portuguese feast in
America; includes entertainment.

Pittsfield
Festival Americana
Features one of the largest
Fourth of July parades in the U.S.

Salem
Salem Maritime Festival
Tall ships sail into port. Boat-
building demonstrations.

Statewide
Massachusetts Gardens on Tour
More than 75 outstanding gardens
across the state open to visitors.

August

Great Barrington
Monument Mountain Climb
Commemorates picnic and
climb during which Melville and
Nathaniel Hawthorne met.

West Tisbury, Martha's Vineyard
Agricultural Society Livestock Show
Old-fashioned county fair with
livestock, baked goods, midway.

September

Boston
Art Newbury Street
Thirty galleries host special
exhibits.

Bourne
Bourne Scallop Fest
Seafood festival with entertain-
ment and children's activities.

Gloucester
Gloucester Schooner Festival
Schooner race, parade of sails,
night parade of lighted boats.

Harvard
Three Apples Storytelling Festival
Storytellers from around the
country.

Harwich
Harwich Cranberry Festival
Beach party, country music jam-
boree, car show, fireworks.

West Springfield
Eastern States Exposition
"New England's Great State
Fair" lasts for 17 days.

October

Cambridge
Head of the Charles Regatta
One of world's largest rowing
events.

Lowell
Lowell Celebrates Kerouac
Readings, tours, art show of
images of the noted writer.

Northampton
Paradise City Arts Festival
Juried show of work by 180
craftspeople and fine artists.

Topsfield
Topsfield Fair
Agricultural exhibits and fall
flower show, giant pumpkins.

November

Boston
*Boston International Antiquarian
Book Fair*
One of oldest and largest in U.S.

Ellis Memorial Antiques Show
Second oldest charity antiques
show in U.S.

Plymouth
The Pilgrim Progress
Thanksgiving day reenactment.

Springfield
Bright Nights at Forest Park
Holiday lighting arrays continue
to early January.

December

Boston
First Night
Art-based celebration of New
Year's Eve began in Boston.

Reenactment of Boston Tea Party
Traces the action from Old
South Meeting House to Tea
Party Ship at Congress St. Bridge.

Stockbridge
Main Street at Christmas
Re-creates Norman Rockwell's
Main Street at Christmas.

WHERE TO GO
Museums, Attractions, Gardens, and Other Arts Resources

Call for seasons and hours when open.

Museums

**AFRICAN MEETING HOUSE/MUSEUM OF
AFRO AMERICAN HISTORY**
46 Joy St., Boston, 617-742-1854
Oldest standing black church in America was an
Underground Railway stop and center for the
Abolitionist movement.

AMERICAN TEXTILE HISTORY MUSEUM
491 Dutton St., Lowell, 978-441-0400
Almost 100 exhibits in the world's largest textile
museum trace the history of the industry from
Colonial times to present.

CAPE ANN HISTORICAL MUSEUM
27 Pleasant St., Gloucester, 978-283-0455
Exhibits the largest collection of paintings and draw-
ings by Fitz Hugh Lane, along with works by other
notable artists drawn to the Cape Ann landscape.

STERLING AND FRANCINE CLARK ART INSTITUTE
225 South St., Williamstown, 413-458-9545
Best known for its extensive collection of French
Impressionist paintings, the museum also has a sig-
nificant collection of American works.

COMPUTER MUSEUM
300 Congress St., Boston, 617-423-6758
Interactive facility traces the development of com-
puter technology and its social and industrial impact.

DECORDOVA MUSEUM AND SCULPTURE PARK
51 Sandy Pond Rd., Lincoln, 781-259-8355
Exhibits focus on contemporary New England artists;
outdoor sculpture is sited throughout the grounds.

HARVARD ART MUSEUMS
*Fogg Art Museum and Busch Reisinger Museum,
32 Quincy St., Cambridge; Sackler Museum,
485 Broadway, Cambridge, 617-495-9400*
Adjacent museums present well-selected art history
survey with strengths in ancient and Asian art,
Gothic and Renaissance art, French Impressionism,
and German Expressionism.

HARVARD MUSEUMS OF NATURAL HISTORY
24–26 Oxford St., Cambridge, 617-495-3045
Collections include animal, fossil, gem, and mineral
specimens, plus the Blaschka glass flowers.

HISTORIC DEERFIELD
The Street, Deerfield, 413-774-5581
Fourteen preserved 18th- and 19th-century homes
display two centuries of decorative arts.

ISABELLA STEWART GARDNER MUSEUM
280 The Fenway, Boston, 617-566-1401
Venetian-style palace holds remarkable art collection
assembled by its namesake and offers series of con-
certs and lectures.

MIT MUSEUM
265 Massachusetts Ave., Cambridge, 617-253-4444
Exhibits on history of technology include striking
Harold Edgerton stroboscopic photographs and con-
temporary holographic art.

MUSEUM OF FINE ARTS
465 Huntington Avenue, Boston, 617-267-9300
One of America's largest art museums, with more
than 1 million objects, including Revere silver,
Copley portraits, encyclopedic Asiatic art collection,
and Monet paintings rivaled only in Paris.

NANTUCKET WHALING MUSEUM
13 Broad St., Nantucket, 508-228-1894
Former whale oil refinery houses exhibits related to
the island's first industry.

NEW BEDFORD WHALING MUSEUM
18 Johnny Cake Hill, New Bedford, 508-997-0046
Whaling artifacts include a half-scale model of a
whaling bark.

NEW ENGLAND QUILT MUSEUM
18 Shattuck St., Lowell, 978-452-4207
Changing exhibitions of traditional and contem-
porary quilts.

NEW MUSEUM AT THE JOHN F. KENNEDY LIBRARY
Columbia Point, Boston, 617-929-4523
Extensive video clips illuminate major issues in the
political career of the 35th president.

PEABODY ESSEX MUSEUM
132 and 161 Essex St., Salem, 978-745-9500
Historic buildings and artifacts document Salem's
dominance of overseas trade and life at home.

PEABODY MUSEUM OF ARCHAEOLOGY AND
ETHNOLOGY
11 Divinity Ave., Cambridge, 617-495-2248
First museum in the Americas devoted exclusively to
anthropology has extensive collection of artifacts of
the native peoples of the Americas and Oceania.

NORMAN ROCKWELL MUSEUM
Rte. 183, Stockbridge, 413-298-4100
The museum has the largest collection of Rockwell's
original art; his last studio is located on the extensive
grounds.

SPRINGFIELD LIBRARY AND MUSEUMS
The Quadrangle, Springfield, 413-739-3871
Four museums with complementary holdings in art,
science, and local history frame a grassy quadrangle.

WORCESTER ART MUSEUM
55 Salisbury St., Worcester, 508-799-4406
New England's second largest art museum spans
5,000 years of art and culture.

Attractions

ADAMS NATIONAL HISTORIC SITE
1250 Hancock St., Quincy, 617-770-1175
Preserved salt-box homes of four generations, includ-
ing presidents John and John Quincy Adams.

BASKETBALL HALL OF FAME
1150 West Columbus Ave., Springfield, 413-781-6500
Exhibits and videos trace history of the sport.

BOSTON NATIONAL HISTORICAL PARK
15 State St., Boston, 617-242-5642
Visitor center provides maps and guided tours of
Boston's 2.5-mile Freedom Trail to 16 sites including
the Old North Church, Paul Revere House, Faneuil
Hall, and USS *Constitution.*

CAPE COD NATIONAL SEASHORE
Salt Pond Visitor Center, Rte. 6, Eastham, 508-255-3421
Orientation films, exhibits, and interpretive programs
guide visitors to beaches, nature trails, forests, and
dunelands.

CRANBERRY WORLD VISITORS' CENTER
225 Water St., Plymouth, 508-747-2350
Exhibits relate history and cultivation of cranberries.

FENWAY PARK
*Yawkey Way, Boston, 617-236-6666 or 617-267-8661
for schedule and tickets*
Guided tours of one of baseball's oldest parks are
offered for those who don't have time to see a game.

HANCOCK SHAKER VILLAGE
Junction of Rtes. 20 and 41, Pittsfield, 413-443-0188
Restored Shaker site features 20 buildings constructed from the 1790s through the early 20th century and the largest collection of Shaker furniture and artifacts in an original Shaker site.

JOHN F. KENNEDY NATIONAL HISTORIC SITE
83 Beals St., Brookline, 617-566-7937
Guided tours of Kennedy's birthplace include taped narration by his mother, Rose Kennedy.

MARBLEHEAD HISTORICAL SOCIETY
170 Washington St., Marblehead, 781-631-1768
A newly opened gallery houses an extensive collection of paintings and sculpture by folk artist John O. J. Frost.

MINUTE MAN NATIONAL HISTORIC PARK
174 Liberty St., Concord, 978-369-6993, 617-484-6156
Encompasses sites of the Battles of Lexington and Concord, including North Bridge and Battle Road.

NEW ENGLAND AQUARIUM
Central Wharf, Boston, 617-973-5200
Situated on the edge of Boston harbor, the Aquarium re-creates several aquatic environments.

OLD STURBRIDGE VILLAGE
1 Old Sturbridge Village Rd., Sturbridge, 508-347-3362
Re-creation of 1830s New England community features numerous special events.

PLIMOTH PLANTATION
Rte. 3A, Exit 4, Plymouth, 508-746-1622
Modest seaside village and costumed interpreters re-create the settlement in 1627; visitors can board a replica of the Mayflower in Plymouth Harbor.

PROVINCETOWN ART ASSOCIATION AND MUSEUM
460 Commercial St., Provincetown, 508-487-1750

Collection includes works by most of the major artists drawn to this summer art colony.

SALEM MARITIME NATIONAL HISTORIC SITE
193 Derby St., Salem, 978-740-1660
Visitor center provides maps and guided tours of historic waterfront, including the Custom House.

WALDEN POND STATE RESERVATION
Rte. 126, Concord, 978-369-3254
Trails lead to the site of Thoreau's cabin.

WESTERN GATEWAY HERITAGE STATE PARK
Freight Yard, North Adams, 413-663-6312
Exhibits trace the building of the Hoosac Tunnel.

Homes and Gardens

ARROWHEAD
780 Holmes Rd., Pittsfield, 413-442-1793
Author Herman Melville wrote *Moby Dick* from this landlocked locale.

CHESTERWOOD
4 Williamsville Rd., Stockbridge, 413-298-3579
The summer home and studio of sculptor Daniel Chester French, best known for "Seated Lincoln" in the Lincoln Memorial.

EMILY DICKINSON HOUSE
280 Main St., Amherst, 413-542-8161
Birthplace and home of the poet.

EMERSON HOUSE
28 Cambridge Tpk., Concord, 978-369-2236
Personal belongings and furnishings reflect the modest lifestyle of the revered writer.

GIBSON HOUSE
137 Beacon St., Boston, 617-267-6338
Gilded Age time capsule was one of the early houses in the new Back Bay.

GROPIUS HOUSE
68 Baker Bridge Rd., Lincoln, 617-227-3956
Bauhaus founder designed this house for his family
and filled it with furniture designed by his friends.

HOUSE OF SEVEN GABLES
54 Turner St., Salem, 978-744-0991
Home of Hawthorne's aunt inspired the novel.

LONGFELLOW NATIONAL HISTORIC SITE
105 Brattle St., Cambridge, 617-876-4491
Elegant home on "Tory Row" was Washington's
quarters during siege of Boston, but is best known
as the home of Henry Wadsworth Longfellow.

THE MOUNT
Junction of Rtes. 7 and 7A, Lenox, 413-637-1899
Writer Edith Wharton's "cottage" in the Berkshires.

NAUMKEAG
Prospect Hill Rd., Stockbridge, 413-298-3239
Berkshire "cottage" designed by Stanford White.

FREDERICK LAW OLMSTED NATIONAL
HISTORIC SITE
99 Warren St., Brookline, 617-566-1689
The grounds of Olmsted's home, Fairsted, represent
an abridged version of his principles of landscape
design. National Park Service headquarters for
historic landscape research.

ORCHARD HOUSE
399 Lexington Rd., Concord, 978-369-4118
Family home of Louisa May Alcott.

HARRISON GRAY OTIS HOUSE
141 Cambridge St., Boston, 617-227-3956
Federal mansion designed by Charles Bulfinch inter-
prets the lifestyle of Boston's early elite.

Other Resources

AMERICAN REPERTORY THEATRE
64 Brattle St., Cambridge, 617-547-8300
Affiliated with Harvard University, ART is one of the
most avant-garde of America's regional theaters.

BERKSHIRE THEATRE FESTIVAL
Main St., Stockbridge, 413-298-5536
Stanford White–designed playhouse epitomizes
summer theater in the Berkshires.

BOSTON PUBLIC LIBRARY
666 Boylston St., Boston, 617-536-5400 ext. 216
Guided tours of the "Palace of the People" include
murals by John Singer Sargent and Puvis de Chavannes.

CHRISTIAN SCIENCE COMPLEX
250 Massachusetts Ave., Boston, 617-450-3790
Site includes modest 1893 church now incorporated
into a larger basilica with the largest Aeolian Skinner
organ in the Western Hemisphere.

JACOB'S PILLOW DANCE FESTIVAL
George Carter Rd. off Rte. 8, Becket, 413-243-0745
Summer performance series of modern, jazz, ballet,
and traditional dance.

MASSACHUSETTS STATE HOUSE
Beacon Hill, Boston, 617-727-3676
Guided tours of Charles Bulfinch's civic masterpiece
are given on weekdays.

SYMPHONY HALL
301 Massachusetts Ave., Boston, 617-266-2378
The Boston Symphony Orchestra's home has been
called "the Stradivarius of concert halls."

TANGLEWOOD MUSIC FESTIVAL
Rte. 183, Lenox, 413-637-5165
Summer home of Boston Symphony Orchestra also
presents rock and pop concerts.

CREDITS

The authors have made every effort to reach copyright holders of text and owners of illustrations, and wish to thank those individuals and institutions that permitted the reprinting of text or the reproduction of works in their collections. Credits not listed in the captions are provided below. References are to page numbers; the designations a, b, and c indicate position of illustrations on pages.

Text

ARLOCO MUSIC, INC.: Excerpt from "Massachusetts," the official folk song of the Commonwealth. Copyright © 1976, 1977 by ARLOCO MUSIC, INC. Reprinted with permission.

The Boston Globe: From "Digging Art" by Mark Feeney from the *Boston Globe,* May 31, 1998. Copyright © 1998 by the *Boston Globe.*

Durgin-Park Restaurant: Recipe for "Boston Baked Beans." Reprinted with permission.

Farrar, Straus & Giroux, Inc.: Excerpt from "For the Union Dead" from *For the Union Dead* by Robert Lowell and excerpt from "Memories of West Street and Lepke" from *Life Studies* by Robert Lowell. Both, copyright © 1959 by Robert Lowell. Copyright renewed © 1987 by Harriet Lowell, Sheridan Lowell, and Caroline Lowell.

Henry Holt & Company, Inc.: From *The Outermost House* by Henry Beston. Copyright © 1928, 1949 by Henry Beston. Renewed © 1956 by Henry Beston.

Houghton Mifflin: Excerpt from *Maritime History of Massachusetts* by Samuel Eliot Morison. Copyright © 1921, 1941, 1949, 1961, © renewed 1969 by Samuel Eliot Morison. Excerpt from "New England Weather" from *Collected Poems, 1917–1982* by Archibald MacLeish. Copyright © 1985 by the Estate of Archibald MacLeish. Both, Reprinted by permission of Houghton Mifflin Company. All rights reserved.

The New Yorker: From *Assorted Prose* (Knopf). Copyright © 1960 by John Updike. Originally in *The New Yorker.* All rights reserved.

Oxford University Press: From *Paul Revere's Ride* by David Hackett Fischer. Copyright © 1994 by David Hackett Fischer and Oxford University Press.

Penguin Putnam, Inc.: From *The Crucible* by Arthur Miller. Copyright © 1952, 1953, 1954 by Arthur Miller. Renewed © 1981 by Arthur Miller. Reprinted by permission of Viking, a division of Penguin Putnam, Inc.

Random House, Inc.: From *Man of the House: The Life and Political Memoirs of Speaker Tip O'Neill* by Tip O'Neill with William Novak. Copyright © 1987 by Thomas P. O'Neill, Jr.

Bob Sargent: Recipe for "Wellfleet Oysters with Hard-Cider Mignonette." Reprinted with permission.

Illustrations

ARCHIVE FUR KUNST GESCHICHTE, BERLIN: **34** Boston Tea Party. Engraving; AMERICA HURRAH ARCHIVE, NEW YORK: **5** Appliqué circle quilt, c. 1845. Cotton. 102 x 102"; **13c** Cushing & White weathervane, c. 1885. Copper. 32" h.; **73a** Sampler by Mary Lockwood, c. 1785. Wool on linen. 13 x 16"; AMERICAN ANTIQUARIAN SOCIETY, WORCESTER: **54a** *Fitz Hugh Lane* by Robert Cooke, 1835; A.T.&T. COMPANY PHOTO/GRAPHICS CENTER: **50a** Dr. Thomas A. Watson; AMERICAN TEXTILE HISTORY MUSEUM, LOWELL: **46** *Woman Tending a Loom* by Winslow Homer. Woodcut; **47** *A View of Lowell* by E. A. Farrar, 1834. Hand-colored lithograph; AMHERST COLLEGE LIBRARY: **86a** Emily Dickinson. Daguerreotype. 3¾ x 3¼"; ATLANTIC MONTHLY: **84a** Cover of *The Atlantic,* 1950; MILTON AVERY TRUST/ARTISTS RIGHTS SOCIETY: **2** *Haircut on Cape Ann* by Milton Avery, 1945. Watercolor on paper. 30 x 22"; **20** *Gloucester Landscape* by Milton Avery, c. 1945. Oil on canvas. 25 x 30". Both, © Milton Avery Trust/Artist Rights Society (ARS, New York); SCOTT BARROW: **101a** Swan boats; BOARD OF SELECTMEN, ABBOT HALL, MARBLEHEAD: **35a** *The Spirit of '76* by Archibald M. Willard, c. 1876. Oil on canvas. 10 x 7½"; BONNIE BENRUBI GALLERY, INC., NEW YORK: **97b** *Camera Obscura Image of Boston View* by Abelardo Morell, 1998. Gelatin silver print; BOSTON BREWING COMPANY: **65b**; BOSTON PUBLIC LIBRARY: **38** *Emigrant Arrival at Constitution Wharf, Boston,* 1857. Engraving; **39a** Bread and Roses strike. Photo *Herald Traveler;* **66** Cartoon; THE BOSTONIAN SOCIETY/OLD STATE HOUSE: **10** Scrimshaw carving. 6¼ x 2½ x 1¾"; **36b** Abolitionist broadside, 1851; **42a** Clipper ship *California,* **44** Ship's figurehead. Wood, painted. 28 x 19½". Gift of John E. Lynch, 1908; **90a** *Bunker Hill Grand Centennial March;* BRIDGEMAN ART LIBRARY INTERNATIONAL, LTD., LONDON: **43** Clipper ship *Highflyer.* Private collection; **49** *Autumn in*

New England—Cider Making by Currier & Ives, c. 1857–1907. Private collection; CHRISTIE'S IMAGES: **1** Drawing from *The Edward Cary*, 1858. Watercolor and ink. 12¾ x 8⅛"; **54b** *Rafe's Chasm, Gloucester, Massachusetts* by Fitz Hugh Lane, 1853. Oil on canvas. 34½ x 48¾"; **72b** Queen Anne chest. 75½ x 39 x 21¼"; CLARK GALLERY AND GALLERY NAGA: **99b** *Monkey Settee* by Judy Kensley McKie, 1994. Cast bronze and walnut. 71 x 28 x 34½"; THE CLEVELAND MUSEUM OF ART: **23** *Hills, South Truro* by Edward Hopper, 1930. Oil on canvas. 27⅜ x 43⅛". Hinman B. Hurlbut Collection, 2647.1931; THE COMPUTER MUSEUM: **101b** Walk-Through Computer 2000™. Photo FAYFOTO/John Rich; CONTACT PRESS IMAGES: **67a** Tip O'Neill. Photo Annie Liebovitz; CORBIS: **26, 68a, 76a, 82a**; NORA FELLER/OUTLINE: **77b** Julia Child; FELICE FRANKEL: **51b** *Diamond Electron Emitters*. Photograph © 1997 by Felice Frankel; ISABELLA STEWART GARDNER MUSEUM, BOSTON: **74** *Isabella Stewart Gardner* by John Singer Sargent, 1888. Oil on canvas. 74¾ x 31½"; **75a** *Courtyard*; **75b** *Diana* by Paul Manship, 1921. Bronze. 37⅞ x 24½"; THE GILLETTE COMPANY, BOSTON: **17b** Gillette razor; THE GRANGER COLLECTION: **32a** *Samuel Adams* by John Singleton Copley, c. 1772. Oil on canvas; **36a** William Lloyd Garrison, c. 1830s. Colored engraving; **56** *A Witch Trial at Salem*. Artist unknown, 1892. Lithograph; **84b** Illustration from *Little Women*; **85b** Thoreau's cabin at Walden Pond; JOSHUA GREENE PHOTOGRAPHY: **70, 71a, 71b, 72a**; PATRICIA HARRIS AND DAVID LYON: **14a** "Beantown" postcard; HASBRO, INC.: **80b, 81b**. THE CHECKERED GAME OF LIFE®, YAHTZEE®, CANDY LAND®, PIT®, ROOK®, RISK®, CLUE®, and MONOPOLY® are trademarks of Hasbro. ® and © 1999 Hasbro, Inc.; HIGGINS ARMORY MUSEUM, WORCESTER: **100b** Photo Don Eaton; ROBERT HOLMES PHOTOGRAPHY: **63, 68b, 100a** Glass flowers; **100c** Mapparium; HOOD MUSEUM OF ART, DARTMOUTH COLLEGE, HANOVER, NEW HAMPSHIRE: **28b** Fancy basket. Ash splints, sweet grass braids. 5½ x 9 x 5⅞". Gift of Patricia W. Clement; JACOB'S PILLOW: **93a** Inside/Out stage; MICHAEL JAMES: **98** *Hive*, 1998. Hand-painted and commercial cotton fabrics, machine-pieced and machine-quilted. 44 x 65½"; SUSAN COLE KELLY: **39b** Saint's day festival; KELLY/MOONEY PHOTOGRAPHY: **21b** Edgartown lighthouse; KOUGEAS GALLERY, BOSTON: **57** *Trinity Church* by Robert Comazzi, 1998. Watercolor on

cold press paper. 8 x 10¼". Collection Kevin Mrazik; **61a** *Big Dig 2* by Carolina A. Reyes, 1997. Oil on canvas. 18 x 36"; BARBARA KRAKOW GALLERY, BOSTON: **96a** *Grotto* (diptych) by Michael Mazur, 1998. Oil on canvas. 76 x 72"; LIBRARY OF CONGRESS: **28a** Wampanoag chief Metacom by T. Sinclair, 1842. Lithograph; **50b** Alexander Graham Bell; **58a** *Old Boston. Beacon Hill, with Mr. Thurston's house from Bowdoin St.* by J. H. Bufford, 1858. Lithograph. After a drawing by J. R. Smith, 1811–12; **61b** Poster advertising the Hoosac Tunnel; **83b** Illustration by Howard Pyle for *Yankee Doodle*, 1881; MARK MACRAE: **17a** Raincheck for 1946 World Series at Fenway Park; **78a**; DAVID MADISON: **78b** Fenway Park; MAGNUM PHOTOS, INC.: **87b** Derek Walcott. Photo Eugene Richards; MARBLEHEAD HISTORICAL SOCIETY: **40a** *Codfish* by John Orne Johnson Frost, c. 1920s. Painted wood. 11 x 26"; MASSACHUSETTS ART COMMISSION: **13a** "Sacred" cod, c. 1784. Carved wood. Commonwealth of Massachusetts State House Art Collection; MICHAEL MCCURDY: **85a** *Thoreau in Cattails* by Michael McCurdy, 1985. Wood engraving. 6 x 8"; JOSEPH MCGURL: **19** *In the Coastal Realm*, 1995. Oil on canvas. 28 x 46". Private collection. Photo Ned Manten; METROPOLITAN MUSEUM OF ART, NEW YORK: **24** *View from Mount Holyoke, Northampton, Massachusetts, after a Thunderstorm—The Oxbow* by Thomas Cole, 1836. Oil on canvas. 51½ x 76". Gift of Mrs. Russell Sage, 1908. 08.228. Photo © 1995 The Metropolitan Museum of Art; **33** *The Midnight Ride of Paul Revere* by Grant Wood, 1931. Oil on masonite. 30 x 40". Arthur Hoppock Hearn Fund, 1950. 50.117. Photograph © 1998 The Metropolitan Museum of Art. © Estate of Grant Wood/Licensed by VAGA, New York, NY; JOEL MEYEROWITZ: **22b** *Ballston Beach*, 1995; MILLICENT LIBRARY, FAIRHAVEN: **29** *Martha Simon* by Albert Bierstadt, 1857. Oil on cardboard. 19 x 13"; MUSEUM OF AMERICAN FOLK ART: **35b** Paper soldier, c. 1840–50. Watercolor, pen and ink on cut paper and card. 4 x 2"; MUSEUM OF FINE ARTS, BOSTON: **9** *Paul Revere* by John Singleton Copley, 1768. Oil on canvas. 35 x 28½". Gift of Joseph W., William B., and Edward H. R. Revere; MUSEUM OF THE CITY OF NEW YORK: **88a** Provincetown Players putting up scenery, 1916. Gift of Max Haas. 34.187.1; **88b** Cigar box card, P. Lorillard Tobacco Company. Theatre Collection; NATIONAL GEOGRAPHIC SOCIETY IMAGE COLLECTION: **12a** Massachusetts

flag. Illustration by Marilyn Dye Smith; **12b** Chickadee and mayflower. Illustration by Robert E. Hynes; **15b**; NATIONAL MUSEUM OF AMERICAN ART, SMITHSONIAN INSTITUTION, WASHINGTON, D.C./ART RESOURCE, NEW YORK: **27** *Snow Fields (Winter in the Berkshires)* by Rockwell Kent, 1909. Oil on canvas. 38 x 44"; NATIONAL PORTRAIT GALLERY, SMITHSONIAN INSTITUTION, WASHINGTON, D.C./ART RESOURCE, NEW YORK: **64** *John Quincy Adams* by D. Needham for Kelloggs & Comstock. Lithograph; **65a** *John Adams* by John Trumbull, 1793. Oil on canvas. 25⅝ x 12½"; **82b** *Nathaniel Hawthorne* by Emanuel Gottlieb Leutze, 1862. Oil on canvas. 29½ x 25"; **83a** *Ralph Waldo Emerson* by George K. Warren, c. 1870. Photograph, albumen silver print. 3⅝ x 2⅜"; **86b** *Henry Wadsworth Longfellow* by Theodore Wust, 1871. Watercolor on ivory. 3½ x 2¾"; THE NEWARK MUSEUM/ART RESOURCE, NEW YORK: **55** *The Fort and Ten Pound Island, Gloucester* by Fitz Hugh Lane, 1848. Oil on canvas. 20 x 30". Gift of Mrs. Chant Owen; PALM PRESS, INC.: **51a** *Cutting the Card Quickly* by Dr. Harold C. Edgerton, 1964. © The Harold E. Edgerton 1992 Trust; PEABODY ESSEX MUSEUM, SALEM: **45** *Crowninshield's Wharf* by George Ropes, 1806. Oil on canvas; **69** *Street in Ipswich* by Gertrude Beals Bourne, 1918. Watercolor on paper; PHOTOFEST: **89** *Good Will Hunting*. © Miramax Films; PILGRIM SOCIETY, PLYMOUTH: **31** *The First Thanksgiving* by Jennie Brownscombe, 1914. Oil on canvas. 36 x 48"; POLAROID COLLECTION: **99a** *Columbine* by Olivia Parker, 1991. Polaroid Polacolor photograph. 20 x 24". Courtesy the artist; PROVINCETOWN ART ASSOCIATION & MUSEUM: **40b** *The Dory* by B. J. O. Nordfeldt, c. 1916. White line woodblock print. 10 x 9½"; **42b** *His First Voyage* by Charles W. Hawthorne, 1915. Oil on board. 48 x 60"; THE NORMAN ROCKWELL MUSEUM AT STOCKBRIDGE: **94a** *Triple Self-Portrait* by Norman Rockwell, 1960. Oil on canvas. 44½ x 34⅜"; **94b** *Stockbridge Main Street at Christmas* by Norman Rockwell, 1967. Oil on canvas. 26½ x 95½"; **95** *The Recruit* by Norman Rockwell, 1966. Oil on canvas. 34½ x 27½". All, printed by permission of the Norman Rockwell Family Trust. Copyright © 1998 the Norman Rockwell Family Trust; **96b** *Norman Rockwell Meets Christo on Main Street* by Libby Barker, 1997. Wood, fabric, enamel, polyurethane, hemp string. 17 x 96 x 16". Courtesy the artist. Photo Paul Rocheleau; THE ROUNDER RECORDS GROUP: **92a** CD cover art for Michelle Willson, 1994; SALANDER-O'REILLY GALLERIES, NEW YORK/BERTA WALKER GALLERY, PROVINCETOWN: **97a** *The Lantern* by Paul Resika, 1996. Oil on canvas. 52 x 60". Collection Jim and Susan Hill; SAN FRANCISCO PUBLIC LIBRARY: **16** Plymouth rock. Engraving; STAGEIMAGE: **90b, 92b, 92c, 93b; 102** Chick Corea. Photo Richard Laird; STOCK BOSTON: **52b, 53a; 103** Concord. Photo Helen Eddy; TIME-LIFE SYNDICATION: **87a** *Robert Lowell* by Sidney Nolan. © 1967 by Time Inc.; UPI/CORBIS-BETTMANN: **67b** John F. and Robert F. Kennedy; **79** Larry Bird; VIRGINIA MUSEUM OF FINE ARTS: **62a** *Boston Park Guide* poster by Charles H. Woodbury, 1895. Lithograph. 19¼ x 12". The Arthur and Margaret Glasgow Fund and The Sydney and Frances Lewis Endowment Fund. Photo Wen Hwa Ts'ao. © Virginia Museum of Fine Arts; VOSE GALLERY: **62b** *Children Sledding, Public Gardens, Boston* by Aiden Lassell Ripley, 1927. Oil on canvas. 30 x 36"; BRUCE WHITEHILL: **80a, 80b, 81a, 81b**. All, collection the Big Game Hunter; WINTERTHUR MUSEUM: **73b** Tankards by Paul Revere, 1768. Silver. 8⅜ x 7"; WOODFIN CAMP & ASSOCIATES, INC.: **32b** *The Minute Man* by Daniel Chester French, 1875. Photo Craig Aurness

Acknowledgments

Walking Stick Press wishes to thank our project staff: Miriam Lewis, Joanna Lynch, Thérèse Martin, Laurie Donaldson, Inga Lewin, Kristi Hein, and Mark Woodworth.

For other assistance with *Massachusetts*, we are especially grateful to: Laurel Anderson/Photosynthesis, Natalie Goldstein, Jan Hughes, Isabelle Eaton of the Isabella Stewart Gardner Museum, librarian Doug Southard of the Bostonian Society/Old State House, James Zimmerman of the Provincetown Art Association & Museum, Jane Duggan of the Boston Public Library, Kelley Pagano of the Norman Rockwell Museum, Ron Scherl of StageImage, Softie Kage of Joshua Greene Photography, Christine Hoey and Mark Morris of Hasbro, Inc., Gillian Kahn at the *Atlantic Monthly*. Michael McCurdy, and Robert Holmes.